Mythomania

Mythomania

Fantasies, Fables, and Sheer Lies in
Contemporary American Popular Art

BERNARD WELT
with *The Dark Side of Disneyland*
by Donald Britton

Art issues. Press
Los Angeles

Art issues. Press
The Foundation for Advanced Critical Studies, Inc.
8721 Santa Monica Boulevard, Suite 6
Los Angeles, California 90069

This publication has been made possible through the generous support
of Lannan Foundation. Additional funding has been provided by the Bohen
Foundation and the Challenge Program of the California Arts Council.

Series editor: Gary Kornblau
Designed by Tracey Shiffman
Printed by Delta Graphics

Manufactured in the United States of America

Library of Congress Cataloguing in Publication Number: 96-84717

International Standard Book Number: 0-9637264-3-9

Contents

6 List of Illustrations

7 Preface

14 We Are the World

18 Faster, Itchy and Scratchy! Kill! Kill!

24 Splendor and Misery of *JEOPARDY!*

29 My NEA Grant Application

35 Steven Spielberg and God

41 St. Dorothy of Oz

46 The Nature of Drag

52 The Gay Deceivers

58 One Man's Meat

63 Soul Party

71 Pee-wee's Plaything

78 Jason Voorhees, R.I.P.

84 The Final Frontier

89 Now *Voyager*

95 The Age of Seuss

102 A Season in Sesame Street

108 Out of Aladdin's Lamp

113 The Dark Side of Disneyland,
 by Donald Britton

127 About the Authors

ILLUSTRATIONS

COVER Photograph by Tracey Shiffman.

PAGE 13 David Robbins, *Prop*, 1988, bronze plaque (unique), 6" x 12".
 Courtesy of the artist and Feature, New York.

PAGE 15 Michael Jackson with Ronald and Nancy Reagan. Anonymous journalistic
 photograph, ca. 1988.

PAGE 20 *The Simpsons*™ © 1994 20th Century Fox Film Corp. All rights reserved.

PAGE 25 *JEOPARDY!* © 1989 Columbia Tristar Television. All rights reserved.

PAGE 36 Steven Spielberg upon receiving an award for *Schindler's List*.
 Anonymous journalistic photograph, ca. 1994.

PAGE 37 *Schindler's List* © 1993 Universal City Studios, Inc. All rights reserved.

PAGE 42 *The Wizard of Oz*, A Metro-Goldwyn-Mayer Picture © 1939 Loew's, Inc.
 All rights reserved.

PAGE 43 *Joan of Arc* © 1948 RKO Radio Pictures, Inc. All rights reserved.

PAGE 47 *The Adventures of Priscilla, Queen of the Desert* © 1994 Gramercy Pictures.
 All rights reserved.

PAGE 54 *The Gay Deceivers* © 1969 Fanfare Film Productions, Inc.
 All rights reserved.

PAGE 60 *Sex* © 1982 Gay Sunshine Press; *Meat* © 1981 Gay Sunshine Press;
 Smut © 1984 Boyd McDonald, published by Gay Presses of New York.

PAGE 64 *All of Me* © 1984 Universal City Studios, Inc. All rights reserved.

PAGE 69 *Back to the Future Part II* © 1989 Universal City Studios, Inc.
 All rights reserved.

PAGES 72-6 *Pee-wee's Playhouse* © 1987 Paul Rubens. All rights reserved.

PAGE 80 *Friday the 13th Part V—A New Beginning* © 1985 Terror, Inc. All rights reserved.

PAGE 85-7 *Star Trek* © United Paramount Network. All rights reserved.

PAGE 90 *Star Trek Voyager* © 1994 United Paramount Network. All rights reserved.

PAGE 95 *The 500 Hats of Bartholomew Cubbins* © 1938 Dr. Seuss, renewed 1965
 Theodor S. Geisel and Audry S. Geisel. All rights reserved.

PAGE 96 *Horton Hatches the Egg* © 1940 Dr. Seuss, renewed 1968 Theodor S. Geisel and
 Audry S. Geisel. All rights reserved.

PAGE 99 *Gertrude McFuzz* © 1958, renewed 1986 Theodor S. Geisel and Audry S. Geisel.
 All rights reserved.

PAGE 100 *If I Ran the Circus* © 1956, renewed 1984 Dr. Seuss Enterprises, L.P.
 All rights reserved.

PAGE 104-7 *Sesame Street* © 1980 Children's Television Workshop.
 All rights reserved.

PAGE 117 Photograph by Donald Britton.

PAGE 127 Photograph by Colby Caldwell.

Preface

I WOULD CALL THE SUBJECT of the essays in this book "the art of commercial culture" rather than "popular art," but the phrase might be read pejoratively. I am not sure if the contempt for commercial success that is usually found in art circles—excepting work so manifestly brilliant that its odor of vulgar fame is transformed into glamour, as with Charlie Chaplin's films—is anything more than sour grapes. But high art—and what else should we call it, unless, with brutal frankness, we designate it *unpopular* art?—does not remove itself from the system of commerce merely by pricing itself out of the popular audience's reach, necessitating subsidy by government agencies, obscure European nobility, and tobacco peddlers; nor yet by concerning itself exclusively with questions that can only be of interest to curators and graduate students, who are a smaller but flashier part of the system of commerce. By the same token, popular art does not diminish its significance by resting unapologetically in its unambiguous position—by seeking to gain our dollars by showing us what we like to see. Maybe this doesn't need stating, but it does seem as if an awful lot of people—critics and artists among them—fail to recognize that in America, the vulgarity inevitably associated with commercial success is not a dangerous opiate, distracting us from eternal truths. In America, vulgarity is the *vehicle* for the expression of eternal truths.

I deliberately use the phrase "popular art" rather than "popular culture," which always seems to suggest a disembodied expression of the *Zeitgeist*, because I am sorry to see popular art, and the artists who make it, fail to achieve the respect they deserve.

Sometimes popular art is dismissed because of the prejudice that what is entertaining cannot be serious. We inherit from avant-gardism the idea that artworks can or should shock an audience out of its complacency. These days, however, high art of the galleries and museums is far more likely to shock an audience *into* complacency. Since, in the society of the spectacle, practically everything that "serious" art does to avoid merely entertaining—challenging, distressing, and even edifying the audience—itself constitutes entertainment, I am not sure that stigmatizing popular art alone as entertainment can be justified. So I prefer to stigmatize entertainment by calling it art. In taking Disney's *Aladdin* seriously as metafiction, or proclaiming Dr. Seuss an artist/poet in the line of William Blake, I mean to enhance the pleasure of artworks whose popular appeal is well established—not to puncture it.

I have tried to offer some appreciation of what popular art does well, and has done particularly well in our own time. There have already been enough vague, narcissistic, self-justifying or self-flagellating attempts to characterize the moment we live in. But the past fifteen years or so have indeed seen some kind of genuine realignment of genres in popular narrative art forms, away from realist premises and toward the embrace of fantasy, and if it is not some kind of antemillenial blip, this represents a real if gradual shift in the assumptions of two centuries of prose fiction, drama, and film, which held fantasy to be the extraordinary and inferior case. The unprecedented enthusiasm for horror films in the 1980s, the domination of best-seller lists by genre novels, and the critical as well as popular success of science fiction and cyberpunk in the 1990s are only examples of the trend.

Maybe it is part of a general change in American culture that has been welcomed and deplored as a new age of faith, a giddy plunge into the irrational that runs across lines of party and sect, embracing the politics of compassion as well as stern but fuzzy family values, and New Age spirituality along with new-fashioned fundamentalism. It remains to be seen whether this is not an age of *bad* faith. But I know two things: First, it is happening because it makes someone money, and will continuing happening until it stops

making someone money. (Christian evangelism didn't find television as a way of spreading its message; television found evangelism as a way of extending its market.) Second, it has something to do with the hypnotic trance we fell into around the time of Ronald Reagan's first televised address to the nation, when it first occurred to us that we had actually begun living in a movie. Raging neoconservatives or raving multiculturalists, we are still haunted by the Great White Father, and like it or not, we remain in the Age of Reagan until we are freed by the next great paradigm shift.

This is also the era when the most popular of popular art forms, television, has become more interesting than film, the novel, or high art. (With the advent of VCRs, television swallowed the cinema whole.) What interests me particularly among television's fantasies is the paradox of the representation of the sublime and the timeless in what must be accounted the *smallest* medium for narrative art. I have tried to give the flavor of this aspect of recent televisual culture by treating the game show as a ritual of apotheosis, and by analyzing *Star Trek*'s use of outer space to represent an indeterminate past and an all-too-certain future. This is also a time when Saturday-morning TV programming has erupted into the cutting edge of popular art. As the cultural lead passed to teenagers in the 1950s and '60s, it passed on to children sometime in the 1980s. I have paid homage to *Pee-wee's Playhouse* and *Sesame Street* by considering them as inheritors of the avant-garde's celebration of the polymorphously perverse.

At the same time, and perhaps for not entirely unrelated reasons, the country has gone gay. In addition to the emergence of a vanguard of gay identity and culture, our age is characterized by a homoerotic frenzy in popular art, often mingling fear and desire in the most lurid fashion. (Even the fantasied threat of homosexual power is a homosexual fantasy.) I discuss how popular art half-heartedly attempts to drive off the lingering smell of homosexuality in the bastions of the male heterosexual ideal: the military and the straight porn industry.

The essays included on Michael Jackson and supernaturalist fantasy films address the very 1980s issue of marketing the self; and

the contemporary debate over the representation of violence in popular art is the subject of essays on the dysfunctional family romance in television's *The Simpsons* and the *Friday the 13th* films. I have only occasionally reached outside the Age of Reagan to treat works that still play a significant role in the popular imagination, such as *The Wizard of Oz* and Dr. Seuss's books. This fairly wide swath through fantasies of our time brings together topics that might otherwise be confined to the distant academic camps of Children's Literature and Queer Theory (for example). Like a good child of television, I believe there is always something to be gained from unexpected juxtaposition.

Aside from its snappy and flippant ring, the term "mythomania"—which technically denotes the pathological compulsion to lie—seemed an appropriate title for this series of articles because I wanted to pursue the simplest notion of imaginative activity as making things up, without necessarily judging the fantasies of popular art as sound or suspect. Of course, there are two ways to consider myth: First, there are the narratives that tell us where and how a people find meaning in the world (the Adam and Eve, Oedipus, Twilight of the Gods kind of myth). And second, a still-more common meaning deprecates myth as a widely held, patently false belief. Popular art often partakes of myth in the first sense because it really does address basics and universals that transcend the contingencies of social forms, but it is more often cited for its participation in myth in the second sense, as a means of promulgating ideology (as though it were more prone to do so than high art). As often as I feel moved by the expression of great truths in the humble forms of animated films and children's books, I invoke both senses of myth intentionally.

In using an unfortunately loaded term like "ideology," I don't mean to suggest that art is vitiated (or tainted) by the ideology it expresses. I resent the currently widespread and ill-considered thesis that good artworks are built on good ideas, and the worse corollary that invalid ideas make illegitimate art—the whole tendency to see artworks in terms of allegiance to the ideas they supposedly express, to interpret them as arguments to be rebutted. On the contrary, it

always seems to me that (in a novel or film, anyway) ideology is there like the characters or plot: It is what there is to talk about. Furthermore, it is just as much a fiction as the persons and events depicted. Believing that everything we have to say about the world is necessarily tentative, partial, flawed, and clumsy, I am more inclined to be impressed by an imaginative fantasy than to be shocked by its reactionary implications, if it is not entirely vicious.

At the same time, nothing in these essays has given me as much pleasure as uncovering truly bizarre conceptions underlying some pretty conventional popular art. If I were really pretentious, I would have stolen for this book the title of Sir Thomas Browne's amazing treatise, whose 350th anniversary we observe this year: *Pseudodoxia Epidemica* [False Beliefs Found Everywhere]. If there is one thing I would be happy to say I have done in these essays, it is to state the obvious.

I am especially grateful to David Cobb Craig, Donald Britton's literary executor, for making "The Dark Side of Disneyland," which was first published in the journal *Art issues*, available for republication. I asked to include the essay here because it fits so well, although I am still a little intimidated by its lucidity of thought and style. Until I reread the essay after several years, with a view to including it in this book, I hardly realized how much I was inspired by Donald's example; happily, I had the chance to tell him so before his death, from complications associated with AIDS, in 1994.

It was only after the initial publication of the article reprinted here (in revised form) as "Soul Party" that I came across Parker Tyler's brilliant essay on a similar theme in films of the 1930s and '40s, "Supernaturalism at Home." The coincidence led to a continuing influence I am glad to acknowledge.

I am grateful to Gary Kornblau for finding a home for my eccentric essays in *Art issues*, in which they all originally appeared, for nurturing them on so many occasions, and for offering me the opportunity to rethink and rewrite them; and to David A. Greene for the compliment of assiduous copy-editing. I would like to

thank the staff and supporters of the Virginia Center for the Creative Arts for providing a hospitable environment for the revision of the manuscript. Grady T. Turner and Colby Caldwell expressed as much interest in these essays as if they were themselves responsible for them. Michael Baumgart, Joshua Saul Beckman, David Cobb Craig, David Del Tredici, Nan Fry, Libby Lumpkin, Martha McWilliams, Ilona Popper, and Diane Ward offered helpful responses and encouraging words when they were most needed. And as always, and in all things, thanks to Arthur.

⌊JUNE 1996

HERE YOU LEAVE TODAY
AND ENTER THE WORLD
OF YESTERDAY, TOMORROW
AND FANTASY

We Are the World

MARCH 1992 AS ART CONTROVERSIES GO, it was pretty slight—hardly in a league with flag desecration or Mapplethorpe-bashing. As a public event, however, the excising of four minutes of tape from the end of Michael Jackson's *Black or White* video, after it had already been seen by an audience of many millions, constituted image management on a truly grand scale. After all, who really goes in for political protest or downtown art? *Everybody* watches television.

Michael Jackson may be the most famous performance artist in history. And if, as has been hinted, he deliberately filmed, at unimaginable expense, a dance sequence incorporating crotch-grabbing and wanton vandalism in order to arouse a demand for its suppression, he may show an audaciousness on a scale with his disposable income; but he is still doing nothing more or less than what other performance artists do: seeking an audience by any means necessary. In popular culture, and especially in television, all art is ephemeral and expendable; in the world of high art, self-promotion is the sole accessible content of whole careers. By generating controversy and then immediately altering his work in response, Michael Jackson would appear to have offered a definitive instance of the difference between show business and art: the desperate need to please the general public versus the equally banal compulsion to exhibit scorn and contempt for it. (This is why Liza Minnelli is an entertainer while Roseanne is an artist. Artists who fantasize about making a splash in the wider pool of popular culture should be warned that the key element in entertainment is abject groveling.) The self-crowned King of Pop, however, is a special case:

His art *is* show business, as the show business of entrepreneurial artists like Jeff Koons is, at least arguably, art. Michael Jackson's chosen aesthetic territory is the characteristic failure of show business to confront what is still, perhaps disingenuously, called "reality." The redemptive power of fantasy is the only value he promotes, or indeed appears to comprehend, and niceness is his peculiar genius.

Some superstars, like Barbra Streisand, seem to take pleasure in their public image as tough-as-nails survivors, victors in the weary but ineluctable struggle for glory. Michael Jackson, on the other hand, portrays himself as a victim of his own celebrity, in

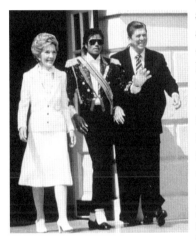

effect marketing his own self-marketing as part of his mystique. What in a real adult might be considered a calculating obsession with wealth and power is, in his case, accepted as a childlike, and therefore benign, hunger for approval. Michael's innocence makes so powerful an appeal that the masses are willing to believe he simply didn't foresee that the video would upset anyone; of course, children don't understand that it's wrong to destroy property or touch yourself "down there." The former child-star who named his private estate Neverland sells the idea of childhood as a form of special pleading. To deny the innocence of Michael is to deny the innocence of childhood.

The actual children appearing in the *Black or White* video, appropriately enough, invert the adult star's arrested development. They are hard, knowing kids, overpainted, overcoiffed, and overdressed—grotesque parodies of adult consumerism. It is easy to dismiss as either maudlin or cynical the sacred law of television that children's first duty is to be cute, and that they grow cuter still in direct proportion to their imitation of behavior objectionable in adults. But the depiction of children as conspicuous consumers

is also a fantasy representation of the adult consumer as a child, absolved of all responsibility. Ostensibly a statement that race is of no real consequence in the global village, *Black or White* more cogently portrays the fantasy that there are no consequences in international economic life. This is the substance of the American Dream, and its vehicle in Michael Jackson's video is also a fundamental theme in American culture, played out on a global scale: the self as commodity. For the price of a little rhinoplasty and an exotic costume we can make ourselves anew, buying our way to wisdom and harmony—to what they are calling, these days, "excellence." The video's appropriation of the dance traditions of Africa and Asia is reinforced by an impressive shot that places Jackson against a background of the Sphinx, the Parthenon, the Taj Mahal, and other national symbols, like a tourist among his bronze souvenirs. For a moment, he is literally ensconced in the Statue of Liberty and assumes her inspiring, huddled-masses-welcoming pose. (That's *Miss* Liberty, to you.)

But the new imagery of multiculturalism looks suspiciously like the old image of American hegemony. The video's most notoriously expensive segment, in which vacuously grinning models of varying national origins are transformed, by a computer process known as morphing, into a rapidly changing "face of humanity," is clearly intended to suggest that differences of race are too superficial to count for much in the brave new world whirling around us. Maybe it effectively communicates that message, but it also comments, in an oddly self-conscious way, on the core of Michael Jackson's personal myth: his eccentric determination to remake himself according to his own skewed vision of beauty, as a being neither too black nor too white, too male nor too female. At some level, the changing face of Michael Jackson hurls back at popular culture in horrifying form its own insistence on blandness and homogeneity, as if the only way to imagine people of different backgrounds uniting were to throw them all in a blender and flip the switch. As interesting as it has been over the past decade or so to observe this unprecedented metamorphosis of a public figure, this version of transcendence of corporeal limitations carries about as much

punch as a United Colors of Benetton ad campaign. And apparently, the message is also much the same: In the global marketplace, you can be whoever you want to be, as long as it isn't simply *you*, unadorned and unaltered by commerce. Having *is* being.

It is tempting to read the suppressed final sequence of the *Black or White* video, in which Michael Jackson takes out his aggression on an automobile, as an allegory: The American culture industry vents its frustration over the United States' concentration of its last-ditch efforts at global domination on coercing the Japanese to buy American cars, when it's obvious that the world is hungering for American music, movies, jeans, and hairstyles. Living is an art, and lifestyle—from plastic surgery to fashion accessories to hyperbaric chambers—is the most characteristically American art form. The next President of the United States may find his or her role reduced to travelling representative of the American image business, opening a Hard Rock Cafe in Bucharest, an All-American Boy in Botswana, a Kentucky Fried Chicken franchise in Ulan Bator. It's a small world, after all.

Faster, Itchy and Scratchy! Kill! Kill!

⌊NOVEMBER 1994 THE CLOUDS PART, heavenly voices intone the sacred
name, and then there appears before us, viewed as from far above
our daily cares—well, just the whole world, that's all. As seen on
TV. All of popular culture, high and low, as though programmed
for the edification of our nation's youth by some demented and
incredibly tuned-in E.D. Hirsch. Nothing on television has ever
attempted to appropriate so entirely the whole of the cultural mo-
ment as it flies past, with the possible exception of Johnny Carson's
monologue, *olov ha-sholom*. Bart Simpson dreams of Bosch's
Hell and wakes to the vision of a doctor straight out of *The Cosby
Show*. Bigfoot, Gilbert and Sullivan, *Terminator II*—all are swal-
lowed whole and spit out again, transformed into a cartoon, into
television, into Art.

Who are these Simpsons? Is it our customary 3-D universe
they inhabit, or do they lead a more rarefied existence, perched
on a timeline of cartoonly nuclear families midway between the
Flintstones and the Jetsons? In weekly increments they seem to
grow and change like the fictional characters in the honored narra-
tives of our past: Bart learns the meaning of friendship, Homer
learns to value his wife and children over beer and pork chops. But
with the next episode, they have unlearned their lessons and are
right back where they started. Each week the Simpsons and their
cohorts are imperiled and rescued, not just from injury or death
but from the loss of essential identity: Will Lisa do something wrong?
Will Bart do something right? Mr. Burns may be sued by Homer
or painted nude by Marge, but when next we see him, he is once

again sputtering and demanding of Smithers just who these pesky proletarians might be. In the long run, nothing that happens to them—sudden fame or penury, alcoholism, the threat of divorce—nothing in the Simpsons' exemplary, imaginary lives lasts beyond a single half-hour episode; nothing changes them for the better or for worse.

Is this amnesia, this ineducability, due to their unreal condition as cartoon characters? Or are they really, seriously, the typical late-twentieth-century American family? Is there, at this point, an appreciable difference?

What is the difference between television and life? All right, I *know* what it is, but I can't believe I'm alone in forgetting it completely from time to time—like whenever I turn on the TV. Still, I also know that these Simpsons, for all their up-to-the-minute dysfunction and co-dependency, will always be more like the Waltons or Brady Bunch than they are like my family, or yours—even as they, quite self-consciously, fret and flagellate themselves for falling short of television-imposed standards for family life. They may be as much in thrall to television as we are, but they *are* television, which makes them different—I think. They are also television *about* television, a genre that has been around since the days when television-viewing first won its place as the core observance of American private life (circa *The Dick Van Dyke Show*) and now pops up everywhere, in naïve and sophisticated forms (*Murphy Brown* vs. *The Larry Sanders Show*). Television about television is obviously a kind of art about art, but television about television is significantly different from art about art because The American Family does not spend six to eight hours a day in front of art.

Like all other children in America, Bart and Lisa watch cartoons on Saturday mornings and after school. Itchy (or is it Scratchy?) garrotes, beheads, explodes, electrocutes, shoots, stabs, slices and dices Scratchy (or is it Itchy?). Like all other children in America, Bart and Lisa laugh with delight. Is this "violence on TV"? No, there is no violence on TV, there is only the representation of violence on TV. So is this the representation of violence on TV, or is it the representation on TV of the representation of vio-

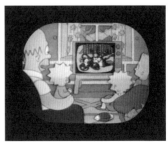

MATT GROENING

lence on TV? What is this violence *for*?

This is not a haughty theoretical issue. Advocates of control and non-control of violence on television are very publicly arguing about the effect these depictions have on the home audience, especially on children. But—perhaps because they are more accustomed to thinking about society than about art—neither side appears much concerned about the fact that what violence does to its audience depends more upon what it communicates to them than upon what is depicted, shot by shot by shot. The discussion is framed as though the violence on *Nightline* were equivalent to the violence committed by Tom upon Jerry (or is it Jerry upon Tom?). It is hard to admit that the depiction of violence—like the depiction of sex, of eating, or of television-cartoon-watching—communicates ideas, as art will do; and different ideas depending on, among other things, the mode of depiction, its structure, and its context.

Bart and Lisa may be laughing at the violence in the *Itchy and Scratchy* cartoon because they represent a post-X generation scarifyingly desensitized by TV. But the rest of us—those of us who are real, or imagine we are—aren't laughing at the violence; we're laughing because the violence in an *Itchy and Scratchy* cartoon *isn't* violence. Our laughter is as complex an aesthetic transaction as can be found in television culture. We're laughing first because this representation of violence is brilliantly conceived and outlandishly extreme; then because it is not a representation of violence as such but a representation of "the mindless violence children watch on TV" (the *ain't it the truth* response); and then because we're aware that *that* representation is a subversive joke directed at those who confuse real violence with its representation on television—to the extent of tilting at images while the real social roots of real social violence remain unaddressed.

We are also laughing because we know we are watching a cartoon—as adults, yet. The mere existence of *The Simpsons* is an assault on a central convention in commercial culture, that there must be one set of rules, cultural forms, and topics of discussion—in short, one world—reserved for children and another for grown-ups. The form of the cartoon comes to stand for all that is repressed

in the adult world, primarily because it is subjective experience and thus held unproductive: fantasy for children, realism for parents. The *Itchy and Scratchy* cartoon-within-a-cartoon challenges the rule that adults have the natural right to debate, decide, and control what children may do, enjoy, or watch on TV by violating the segregation of parent and child: You think you're in charge here? Then what are you doing watching a *cartoon*?

And then we are laughing because suddenly we realize why, at a deeper level than satire, cartoon violence is funny—not because we watch the characters suffer and die, but because we know they will rise again. We know that whatever harm comes to them, no harm will come to them. That is the difference between cartoons and life. Live-action television, which even in its most innovative forms holds to realist conventions, does not allow for resurrection (or does so only in the guilty pleasures of soap opera and science fiction). Yet even when the flickering images are photographic representations of living actors, part of the pleasure of television programs must be in their iterability: that is, not in the development of character as realism demands, but in the knowledge that the character has done and will do the same thing over and again, in summer reruns and syndication, thus achieving immortality— just as in the good old days of literacy, we were able to turn back to the beginning of the book and bring Anna Karenina or Emma Bovary back to life. With *Itchy and Scratchy*, television fulfills the dire words of the great progenitor of TV comedy, Uncle Miltie himself: "I will kill you a million times." And we see that this is not a threat, but a promise.

It is the Simpsons' rut that convinces us of their immortality; they fail to learn or grow because, like figures in myth, their character is their fate. Would they seem more or less real if the same scripts were to be played by live actors, and the aura of magical bringing-to-life that the word "animation" conveys were missing from the show? What we are seeing cannot be real, because it is television—even when the pictures are of real people, playing characters or playing themselves. What is the difference between the Homer and Marge Simpsons and the O.J. and Nicole Simpsons?

Only the difference between art and reality, and once depictions of reality appear on TV, that difference disappears, in a way that is both terrible and sublime to contemplate. Despite the cartoon family's horrible dynamic, the overweening greed of Mr. Burns, the corrupt politicians, ecological mayhem, and joyless, hopeless institutions of retirement village and elementary school, we have to realize at some level that the violence done in social reality is incalculably worse than anything we see depicted in the cartoon images transmitted into our homes. But the images we see on TV are trapped in the set, and nothing that appears on the TV screen can convey that violence, or change it. Do the Simpsons, who appear to recognize, fleetingly and from time to time, that they are cartoons themselves, ever cut their laughter short with a shudder as they experience their own unreality—the purest, most profound of their responses to the imaginary shows they watch on their own imaginary television? Itchy and Scratchy show us what it is like for these Simpsons to experience their own cartoonliness. They watch the little cat and mouse as we watch them. In the dancing light of television, nothing is real.

We are all Simpsons.

Splendor and Misery of *JEOPARDY!*

MAY 1992 REAL PEOPLE ARE TAKING OVER television. On *Rescue* 911,
they resolve matters of life and death without benefit of Aristotelian
plot structure; on *America's Funniest Home Videos*, they strut and
fret their hour upon the screen without the assistance of make-up
artists, drama coaches, or personal trainers. Here, they are tortur-
ing the family cat and splitting their trousers at a friend's wedding;
on another station, they are dealing drugs and being thrust into
squad cars, in the familiar deputy's-hand-on-head position, like a
clown being stuffed into a jack-in-the-box, spewing bleeped-out,
untelegenic expletives. They are doing, feeling, living their lives—
and it's all being transmitted into our homes for us to stare at, hour
after hour, day and night, as we resolutely refuse to live our own.

Television itself knows something its critics don't: that its
real fulfillment as a medium is not to be found in better news pro-
gramming or higher-quality drama. Information and representation
are merely functions it has borrowed from other, more ancient
media. The high purpose of television, as every geek with a cam-
corder now knows, is as a means of transcendence; and the tran-
scendence it offers is the possibility that someday we ourselves may
be seen on TV.

Long before the advent of "reality programming," television
developed the central ritual of this cult: the game show, which pro-
vides the means for the miraculous transformation from outside the
box looking in to inside the box looking out. This is a passage so
magical, so metaphysical, that it must be accomplished by strictly
observed rites, and marked by a hallowing of the newly exalted

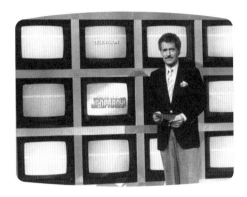

subject. (Indeed, perhaps it is the demystification in shows like *Totally Hidden Video* that critics of the genre are really objecting to. It doesn't seem as though one should be able to get on television without "doing something.") The underlying myth of the game show is, more purely than any plot line ever pursued on *Dynasty* or *Dallas*, the central story of—unfortunately, there is no way of getting around saying this—bourgeois ideology, the crowning of effort with material success. It is not, after all, the rich and famous who appear on *Supermarket Sweep*, but those who must be redeemed from obscurity. The myth is enacted, as in most rites of initiation, as an ordeal, and concluded with "wonderful prizes." Only two currencies, celebrity and riches, have sufficient power in our system of signs to mark this transition from Nobody—a nameless member of the vast and nameless audience—to Somebody: Somebody who's been on TV. And yet the typical contestant doesn't win that much, and isn't famous for that long. The contestant departs "rich and famous" the way Miss America departs from Atlantic City as "royalty": She wears a crown, but that doesn't mean she can order an invasion of Mexico. Not that money doesn't matter, but like virtue, television is its own reward. Appearance on television does

not merely confer temporal powers, quantifiable in dollars and convenient outside the televisual realm. It constitutes a more ultimately significant transformation of state from viewer to viewed.

Thus game shows derive their meaning from the introduction of non-professionals as celebrants of the central mysteries of the higher reality within the little pulsing box. (Special "celebrity" weeks of common game shows are the exception that confirms the rule, as does the fact that we all intuitively grasp that *Hollywood Squares* is *not* really a game show—whatever ghastly hybrid it may actually represent.) Real parents and real children argue and then reconcile, reaffirming their unity, on *Family Feud* as on *Family Ties*; real male bimbos, indistinguishable from their fictional counterparts on afternoon soap operas, swagger and show their sensitivity on *Studs*. To exercise a recently trendy concept, the game show is a "liminal" form, the meeting place between artifice and reality where Mr. and Ms. America are seen to enter into their apotheosis as demiurges of TV's happy land. The rite communicates its awesome powers even to those humble objects whose symbolic manipulation constitutes the playing of the game. On *The Price Is Right*, for example, the flashing lights and turning wheels, the intense concentration of contestants as they try to guess how much an appliance is selling for—above all, the fact that it is all happening on television, before an audience of millions of viewers *just like them*—imbue the products shown with a mystery, a suspense, a *romance* greater than can ever be achieved in real shopping.

Once it is established that the form essentially celebrates the glamour of television itself, and derives its power from the promise of transcendence through appearance on television, it is easy to see why *JEOPARDY!* is the connoisseur's game show, the game show *par excellence*. It is to *Supermarket Sweep* what Samuel Beckett is to Neil Simon, and among game shows, the sole exemplar of true greatness since the days of *Queen for a Day*. *JEOPARDY!* is the purest version of the game show's essential substance—that classical showdown that the Greeks called an *agon*. Each moment and motion on the show is meaningful; none is wasted. There are lights and sound effects, voice-overs and pleasant chats—but

only enough to ensure the fulfillment of the prescribed rites, to show that these are factors in the game-show formula that may never be ignored, though they may be elegantly stylized and condensed as compared with vulgar exemplars. It is all really very Chinese. In place of the glitzy roulette motif of *Wheel of Fortune*, on *JEOPARDY!* we confront the stately grid that coolly represents the contestants' undecided fates and, incidentally, all of human knowledge, through the medium of—What else?—television monitors.

There is a reason why *JEOPARDY!* is the only game show on which contestants do not jump and down, screaming with glee; why Alex Trebek is the only game-show host who could be said to comport himself with dignity, even with a sense of higher purpose; why even the famous theme music is austerely minimalist in its approach. It is not simply the hackneyed association of the show's ostensible subject, the mastery of knowledge, with upper-class manners. *JEOPARDY!* is the one game show that truly appreciates the *seriousness* of what is happening when, through the magic of the game, a member of the viewing audience is briefly elevated to the super-real—as expressed in the status of champion, which must then be defended against new challengers from among the anonymous horde. To the philistine, *JEOPARDY!* is merely a short form of the SAT, glorified as spectator sport; to the true believer, its essence is, as the show's title suggests, the thrilling aestheticization of danger, of risk. What makes appearing on a television game show meaningful is not the need to be a winner, but the need to avoid being a loser—not the dream of victory, but the nightmare of failure, which stands behind all of our culture's mania for success. The contestant on *JEOPARDY!* leaps into the void as no character in a dramatic fiction can do, simply by virtue of being a real person, engaged in a real contest—sweating it out under the heat of real lights in a real room that is also a sacred and uncannily familiar space.

To a nation habituated, by a tradition going back to the Puritans, to the equation of success with merit, *JEOPARDY!* teaches a respect for randomness: In the show's "Double Jeopardy" round, the scores can really change. *JEOPARDY!* cannot seriously contribute to an understanding of the world outside television—after all, it

asks only What or Who, never Why—but it offers at least the homely wisdom that in life we often find the answers first and think of the right questions only later. And anyway, the real purpose of *JEOPARDY!* has nothing to do with spreading knowledge or making a statement. The meaning of *JEOPARDY!* is known to anyone who has imagined being lifted out of an armchair into the ethereal serene of TV, someday to know the feel, in one's own grip, of the sublime and recherché buzzer in place of the greasy, commonplace remote. Contestants, remember to wait until the answer has been read in full: What is Hope? What is Faith? What is Glory?

My NEA Grant Application

DECEMBER 1989 HI, NEA PEOPLE! This is Darren, like it says on the attached form. I know I'm only 16 years old, but I really think I am eligible for your fine grant because I've been published in three (3) magazines: *BITE ME, THE LIMIT*, and *IT STICKS IN YOUR CRAW*, of which I am truly an editor of the last-named, but that is not self-publication because we abstain from voting on our own work. Anyway, I know I am (more than!) ready to live on my own and produce major work if I can only get the money together. I bet you know how it is, because if you're reading this you're probably a writer too.

Even if you can't send me more money than I've ever dreamed of, I hope you will read the enclosed excerpts from my novel that I'm sending, unlike some people who are very encouraging in their condescending *Darren's-written-a-story!* kind of way and then when you ask them what they really thought it's obvious they haven't even *read* it! (*!*) But I think you want to know about the book and not my problems so I think I should tell you it's hard enough sending your work to total strangers without worrying about it being all unfinished and out of context so I want to tell you what it's all actually about then maybe you'll understand why I really need the money to finish it.

OK, my novel is called *NAIL THIS TO YOUR FOREHEAD* because it's not just a story but an important manifesto about what is happening today in the form of a fantasy, like science fiction, which you art-guys may not think too highly of I know but it seems to me that that is where anybody who really thinks about the shape this country or even world is in is at in terms of their career as a writer.

My "heroes" are a small band of writers, musicians and artists—actually they're like a real band and they sing some songs which I've already written—who are forced off the earth by repressive policies so they can't seek self-expression. The irony is that they're like androids and the laws that exiled them were made by living breathing humans who ought to have some sympathy for ordinary human emotions but by this time in our "evolution" they don't so they don't want to see feelings that they don't have anymore ever portrayed in art or music or anywhere. Some of the androids have different powers, like being able to see 360 degrees at once or modular parts they can change (which I'm sure I don't have to explain to you the symbolism of) and they have screens in their foreheads that display what their operating systems are running which is like what they're thinking which is where the title of my novel comes from, but the main thing is that therefore they just can't lie so they believe art is supposed to always tell the truth instead of just serving special interests and since they're so superior to sex and body functions they don't understand why humans who have to do all that stuff find it so disgusting, since to them that's just the way it is, some folks run on batteries and some run on food so they have to shit and like that. Also they can be immortal and stand great heat and cold which helps them in space travel without vessels but confronting human stupidity causes them to endure insufferable pain, like the empath on *Star Trek*, an incredibly hot babe unless that offends you.

So the androids are sent off to different galaxies all over by order of the World President, and everyone thinks they were exiled but really they're on a secret mission to find new worlds to exploit, which they feel bad about but the uncaring President said it was that or the trash heap for them. The President gets his power from promoting policies that make people feel the government is just standing up for decency and The American Family but (more irony) he's really like Caligula and lives a very hedonistic lifestyle that no one knows or talks about outside the elite because he's in control of the arts that could expose the truth and the media will just report things that make people feel good about themselves and

their rulers and their wretched way of life they hold so sacred, which makes my point that control of all aspects of life begins with control of the media of information and opinion. In reality the President only wants power, which in my novel is like literally *power*, which he gets from these very heavy drugs he's a total junkie for that alter your whole body matter into like the stuff they find in pulsars, like rotated particles with strangeness and beauty if you've heard of that, that also have to be synthesized from stuff the androids are supposed to find on the far side of the universe. Also the Pope is a ridiculous slimeball who wants to bottle up everybody's messy juices and pits the sexes against each other for his own power, hiding behind this bogus sky-god/dad guy and he's in on the plot and wants the androids to capture extraterrestrial maidens for his Vatican collection, and cute guys too, why not? And some of the time the androids are whizzing through cold, empty space in a kind of suspended animation which becomes a metaphor for the passivity of the American public during the Reagan years.

So that is when they find out that the universe is full of these prison planets, which is where I am working out some ideas that I think compare favorably to F. Kafka's great story "In the Penal Colony," and also the greatest book of the century *1984* which people should read instead of just seeing the movie and what you'll find in the excerpts I'm sending you. Besides which they also go to: The Planet of Bad High School English Teachers, where they keep saying you're only there for your own good but really all they care about is monitoring your bodily functions and making you follow all these stupid rules that were purposefully invented to be too irrational for any sane person to understand them so you have to stay in your seat and get all embarrassed about asking for a pass to go to the bathroom and have some guy you're always supposed to address as "Coach" feel around to see if you're wearing a jock strap for gym which they care more about than whether you're learning anything real anyway, so there will be a great scene where the prisoners rebel by all exploding at once from every orifice, rolling around in the piss and shit and vomit while the "teachers" helplessly try to restore order. Also the Planet of the Congressional

Representatives from Several Southern States and Parts of Califórnia where whenever you have any kind of sex no matter how "normal" or think a negative thought about your parents or political rulers or your country's great way of life you have to get up and make a public confession, which is just how they convince the prisoners that everybody isn't constantly doing all that stuff all day long every day of their lives anyway. And so on.

Then at the end of their journey they discover the biggest secret of human history, that the earth itself is just one of these prison planets too, founded by aliens, and that all the traditions and customs of all our cultures are just ways to keep people in line, because the aliens who founded these colonies knew that the best way to control people is to let them think they're free; and the real beings in the whole universe inhabit the realm of what we would call imagination as thoughts and feelings and desires and every embodiment of them in matter is only an imprisonment that they cannot bear. Frankly, I am not exactly sure how to work this out yet.

So if this novel sounds like social criticism, it is, in the spirit of the amazing book *Gulliver's Travels*, and I hope you know that Jonathan Swift used a lot of smutty incidents like me as a writer and was obsessed with shit (which I'm not!) like the only genuine teacher I ever had was telling us how he (J. Swift, not Mr. Peck) went crazy because he was obsessed with the image of his beautiful pure clean girlfriend taking a dump, which people my age think is funny but a lot of you guys seem to think is threatening and ought to be totally outlawed from art and what I'm saying is you can't take out that image or "dirty" word without losing the idea it stands for which is knowledge and wisdom about real life and not just trying to shock you. I am sorry if what I have to say offends anybody, like for instance about the Pope, but maybe you can tell me how I can tell the truth about religion or school or our bodies or life or anything without offending anybody. Or if I write about sex, and *please* tell me I'm 16 years old and I'm *supposed* to be thinking about it, it's not just my gonads talking, it's just because sex is a powerful force that is used to control ideas like on deodorant commercials but they can't censor those because there's real money

behind them that supports the military-industrial complex. If people's ideas about sex weren't so messed up maybe they wouldn't be so obsessed with grabbing power like it was an extra dick they could keep handy to fuck someone over with. This is what seems so ridiculous to people my age, that anyone would even try to lie about sex by covering up words and images and be so brain-dead thick they can't even see or want to admit it's all around us all the time but in forms that only serve people in power, which is *really* why, not the subject matter but the effect on the enslaved populace, that it's OK with everybody who wants to follow the leaders out of fear or apathy or whatever. Like *E.T.* is supposed to be this movie that's all sweet and heart-warming and beloved by the American family and I'm only 16 years old and even I can see that this cute little alien is just a big walking, talking *dick*, right? I mean, it's all wrinkled and weird-looking and this kid has just discovered it all by himself and he plays with it and its neck gets all long when it's excited and he has to hide it from his father and it dies but comes back to life again when he needs it most and what does all that add up to but a *dick*, right? But they made it all like *symbolism* so people wouldn't catch on to how it's as much about sex as any picture of a guy with a bullwhip up his ass which is what I hate because they're using it like brainwashing to get people on their side. I think you should just say what you're really saying and if you're talking about dick then just show the people dick, if that's what you're really talking about. The thing is, now they want to make a mystery out of sex like religions do so they can reserve its power to affect ideas for themselves alone. I mean, I know I'm only 16 years old but even I know that when you put a fig leaf on a statue it can't be just a guy's dick you're trying to hide, OK?

People who always want to censor art or worry about whether what it shows is decent are always saying they just want to protect helpless people, but really it must be that they just don't want anyone seeing what life is really like, and not just greedy dried-up old white men in congress but even people who don't ever want anything shown that might look sexist or racist who think they're so liberal or phony bullshit artists who think an idea about their puny lives is so

much more sophisticated than an idea about who's being put down by who in government and society today so they don't even *make* the goddamn art, they just talk about what they could make if they had the energy or maybe the skill that they're lacking to create great art that tells the truth and they mostly live in New York like I was reading about in *Interview* magazine which is full of bullshit anyway.

All I'm trying to say is no matter how hard you try to keep art "pure," some ideas are always going to sneak in and some of them may even be ideas about sex and politics and art itself and who has power and who doesn't and why. So even if they say it isn't really censorship, to refuse to support work like mine that has been left with some shred of an idea about life intact is to establish an official department of propaganda, endorsing only the art that agrees with ten guys in Washington DC that are obsessed with controlling everyone's lives, leaving other artists to struggle and starve like I'm doing now in a suburban basement, living at the whim of the strange creatures who call themselves my parents.

So I sincerely hope this doesn't upset you because I still really want you to send me some money, for which I assure you I would be truly grateful. I can guarantee a drug-free workplace as you require because my friends who hang with me and I would never experiment with drugs or tell anyone about it if we did or really do anything of which you personally or the whole government might conceivably disapprove in any way. I am thinking of making this novel into a screenplay too so even if you can't come up with the funds for me, maybe with your great experience you could let me know if you think there would be any money available somewhere for a movie like this unless it meant totally selling out and even if it did I'd at least be interested in hearing what you think.

Keep defending great art.

Yours forever on all planes of existence and in all time zones,
Darren

Steven Spielberg and God

APRIL 1994 IN THE HALLOWED HALLS of the Dorothy Chandler Pavilion this evening, on the same stage where Tom Hanks is acclaimed for playing a gay man with no sex life, Steven Spielberg enters the cinematic pantheon by calling to the American film industry's attention, rather belatedly, the Holocaust of European Jewry. Whatever its ostensible virtues, *Schindler's List* won its Academy Awards, as always seems to be the case these days, by offering the entertainment community yet another opportunity to congratulate itself on its boundless compassion for the downtrodden and despised. Cigar-store Indians, disabled Vietnam vets, and transvestite political prisoners have all had their moments in the limelight. This year the Oscar goes to . . . the Jews of Poland, ladies and gentlemen.

If our journalists and our politicians and, often, our social scientists habitually confuse films with the events they portray, it is not surprising if Hollywood, as the sacred heart of magical thinking in our culture, does the same. Just as television shows, movies, and rap lyrics depicting senseless violence are condemned as dangerous and reprehensible, to make a film about a hero becomes itself a heroic act. Thus the moral courage of Oskar Schindler, preserver of 1,100 lives, is equated with the aesthetic achievement of the filmmaker who tells his tale and theirs. Terrence Rafferty, writing in *The New Yorker*, holds that the director's feat is "nearly as miraculous" as Schindler's: "His accomplishment is less inspiring than his hero's only because art is less important than life." Is this a tautology or a paradox? Rafferty's praise is less inspiring than Spielberg's film only because criticism is less interesting than art.

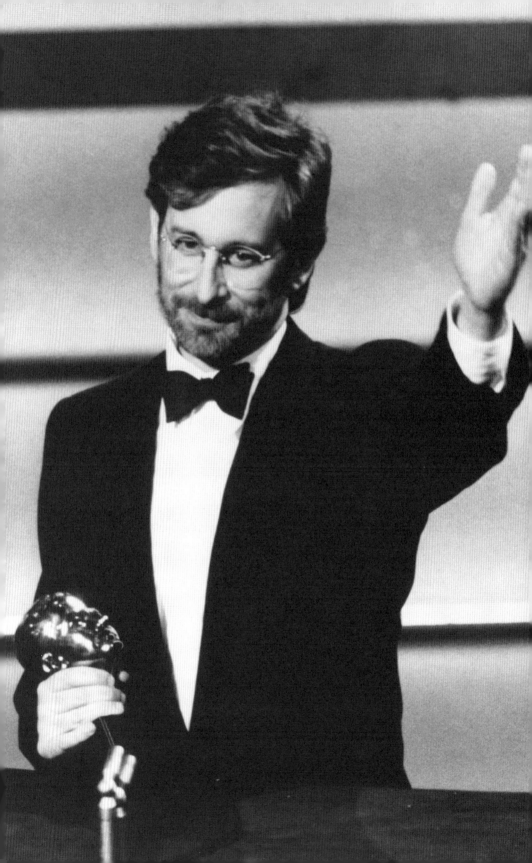

Of course, Spielberg built into his film, as many artists do, the parallel between the storyteller and his main character. The most successful film director of all time has never denied that he is as much an entrepreneur as an artist; in Schindler, who saved Jews from the concentration camps by putting them to work in his factory, he has found a model of doing good while doing well. But it is not the legend of the beneficent industrialist that appeals to Spielberg's fans, in and outside Hollywood, so much as the fable of the purveyor of enormously popular schlock who has finally found the higher, harder path to Art. The cultural relevance of the

Holocaust itself, mind-boggling as this seems, is overwhelmed by the deeper cultural privilege of the myth of individual growth. Today, the boy wonder of the cinema becomes a man.

Through the alchemy of public relations, Spielberg—whose previous attempts at dramatic realism in *The Color Purple* and *Empire of the Sun* failed to earn him Hollywood's respect—appears for the first time as a filmmaker concerned with the accustomed subjects of serious art, and not merely with anthropomorphic sharks, dinosaurs, and space aliens. The irony is that he has finally conquered critics and colleagues only by turning his back on the supernaturalism that won him the public's hearts and dollars, and just when he had a story to tell that ought by rights to be infused with serious religious ideas—one in which the relation of man and the divine should be profoundly called into question.

While pronouncing Spielberg an *auteur du cinéma*, the encomiums for *Schindler's List* have avoided the auteurist strategy of comparison of major works, failing to note that this is hardly the maestro's first cinematic treatment of Nazism, or his first encounter with traditional Jewish belief. In the 1981 blockbuster *Raiders of the Lost Ark*, the evil architects of the Final Solution plot to harness the cosmic power of the God who made His covenant with Abraham, Isaac, and Jacob, by absconding with a sacred object associated with

His cult: the eponymous Holy Ark. They fail in this attempt because of their ignorance of the terrifying power they are unleashing— not because God watches over the world He created, or takes any special notice of the planned extermination of the descendants of His priests. It appears to have gone unnoticed at the time of the film's release that *Raiders'* primitive conception of the divine added an obviously outrageous myth to the screen history of the Holocaust, and casually promoted a revisionist theology far more offensive than anything hinted at in the controversial but essentially ortho- dox *The Last Temptation of Christ.*

Just as *Schindler's List* substitutes dramatic realism for fantasy and black and white for color, it replaces *Raiders'* bizarre theology with no theology at all—only with photogenically reconstructed "documentation" of the experience of the Holocaust's victims. But what is documented is selected to assiduously avoid any funda- mentally religious conception of, or response to, the suffering of the Jews. *Raiders* had the chutzpah to represent God, but sidestepped the Holocaust; *Schindler's List*, in effect, solves the notorious difficulty of representing the Holocaust by offering us a Judaism without God.

It is true that the film is deliberately structured around the depiction of Jewish ceremonial rites, from the lighting of the Sabbath candles that sets the first scene to the ritual laying of stones on Oskar Schindler's actual grave at its end. But though the name of God is liturgically invoked in the Hebrew of their prayers, the Jews of *Schindler's List* are never otherwise depicted as appealing to God, nor indeed questioning His will or His duties to His creation. Their relation to God is *pro forma*. Thus the film memorializes the Jews killed by the Nazis, but at the price of misrepresenting the place of religious ideas in their culture and in their lives. Instead of a relation to the Transcendent and Eternal, Judaism appears solely as a set of family-centered ethical imperatives bound together by a beleaguered ethnic identity.

This is the kind of denatured—as well as naturalized—Juda- ism the Academy of Motion Picture Arts and Sciences can cozy up to: duty to family, responsibility to the community, morality of a

private (Protestant, really), liberally interpreted traditional form. This constitutes the Jewishness depicted in *Schindler's List*: a set of values certainly rooted in traditional Judaism, but more relevantly that of a contemporary middle-class culture of unequivocally enfranchised good citizenship, such as the New Hollywood—chastened by scandal and Reaganism—aspires to. What's missing is what makes Schindler's time utterly different from our own: the experience of a persecuted and culturally estranged minority, depending upon their relation to the Creator of the Universe to sustain them in their sojourn among the gentiles. This is the core of the Judaism of pre-war Eastern Europe, and it's something Hollywood films cannot possibly comprehend or depict.

The miracle of *Schindler's List*, in Hollywood's terms, is that it is supposed to represent the unrepresentable. But what, after all, does this mean? Is it merely that the Holocaust is something we'd rather not witness in all its unpleasantness, like the gothically conceived revelation of the hero's KS lesions in *Philadelphia*? (Is it possible that Hollywood simply cannot make a good movie about human suffering?) Or are film critics just recirculating their notes from the release of Claude Lantzmann's *Shoah* for the popular audience, well aware that the masses would never go so far as to pay to see real documentary images of the Holocaust? Whatever fanatics claim, the mechanics of the Holocaust are extremely well documented, and if we do not know exactly what happened, it is only because we haven't taken the trouble to read the books or consult the pictures that already exist. *Schindler's List* does not reveal the inner meaning of the Holocaust, and no film or thesis is going to, because historical events do not have inner meanings; they have causes and consequences, and these we can find if we seek them. What is meant by the unrepresentability of the Holocaust is simply our inability to assimilate it into our account of the world, due to the prevalence of two myths: first, that civilization means progress toward greater tolerance and humaneness under the rule of Reason; and second, the more ancient idea that Divine Providence directs the affairs of this world and allows no suffering to occur without purpose—a belief accepted at a visceral level even by most nonbe-

lievers. The Holocaust, like so much in the twentieth century, is unrepresentable to the extent that it is obscene—and what is obscene is simply whatever evidence in reality challenges the culture's central beliefs concerning the nature of humanity and of the divine.

In the art of commercial culture, the obscene can be dealt with only by omission. For fifty years, those who have attempted to make sense of the Holocaust have been left with a choice of three obscene theses: that it was outside of God's power; or outside of His area of concern; or part of His divine plan (the most popular, though obviously much the worst of the three). Each thesis challenges the traditional conception of relations between God and the human world, and together they create the great scandal of modern religious faith: that the defining experience of 20th-century Jews is also what forced many to the conviction that God does not exist. In setting this tradition aside, Steven Spielberg does not so much invent a new way to make the Holocaust representable as ignore the problems other filmmakers, writers, and even historians have raised, just as his *Raiders of the Lost Ark* avoided the real evils of Nazism in favor of comic-strip villainy. To do so, he has had to keep God out of *Schindler's List* altogether, revising the world-view of his traditionally religious characters—because to show them directly appealing to their God would raise the obscene issue of His deafness, and shift the focus of the film from 1,100 Jews saved to the 6,000,000 slaughtered. What was missing from Schindler's list were the names of those whom no one saved; what is missing from *Schindler's List* is the name of the God who abandoned them. The goodness of Schindler could be made the film's focal point only by avoiding the question of the goodness of God.

St. Dorothy of Oz

NOVEMBER 1993 UNTIL BILL MOYERS INTRODUCED US to Joseph Campbell in the PBS series *The Power of Myth*, we might have thought of Dorothy Gale, as portrayed by Judy Garland in *The Wizard of Oz*, as an ordinary kid from Kansas with a big voice, a noisy little dog, and *fabulous* shoes. Now, of course, we realize she is an Archetype.

Throughout his career as a popularizer and interpreter of myth, Campbell never had much to say about women as heroes. His thesis was that all quest stories are one. While this is undeniably a meaningful generalization, it trivializes the specific content of disparate myths by blithely ignoring vast cultural differences, cutting all tales to fit one moral. All myth, in Campbell's account, serves to inspire our development of a unique individuality through the courageous journey of self-discovery—what he called "seeking our bliss." Among its other ethnocentric assumptions, this approach notoriously belies the fact that women and men are assigned different goals by all societies, as well as different ways of achieving them, represented by differing plot trajectories for the central male and female characters in traditional narratives around the world.

But there are also real advantages to the comparative method and to recognizing the cogent similarities among tales. Dorothy's story is more than the sermonette it is usually taken for: a parable showing that you *can* go home again, and that—let us all click our heels together three times—there's no place like it. It is a primary modern example of the traditional tale of the daughter (as opposed to son) as hero, with all the limitations that necessarily implies. A comparison to another well-known story of a runaway daughter,

41

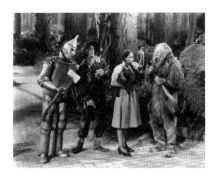

Joan of Arc, may help make the point.

Like Joan, Dorothy is called to adventure against her will. Where Joan's victories are attributed to the intercession of God, Dorothy's are entirely fortuitous: She conquers the two Wicked Witches by sheer happenstance, rather than cunning—or even courage. (Not so much because she is female *per se* but because she is a young girl, Dorothy cannot be allowed the intention of actually harming her enemies, an issue the story of Joan hedges by making her opponents the enemies of the Almighty, and Joan His agent.) Like Joan, she is a leader, an inspiration to her forces, rather than a soldier herself; like Joan, she finds her helpers deficient, and her mission in whipping them into fighting shape. Like Joan, she undergoes the pathos of imprisonment by the evil antagonist. The most significant disparity between the two narratives is the happy ending of the modern tale, as contrasted with Joan's martyrdom. We might say that Dorothy of Oz, virgin hero, is Joan of Arc without the Christian emphasis on exemplary suffering.

As it happens, the director of *The Wizard of Oz*, Victor Fleming, filmed his own *Joan of Arc* nine years later (in 1948), a version that reinforces these similarities and even restyles Joan, as played by Ingrid Bergman, to bring her closer to Dorothy—just as the author of the Oz books, L. Frank Baum, may conceivably have found his original inspiration for Dorothy in the figure of Joan. Without making a case for Fleming as an auteur, the use of *mise en scène* to emphasize parallels between the two stories is striking. The opening of Fleming's *Joan of Arc* envisions Joan in pictorial

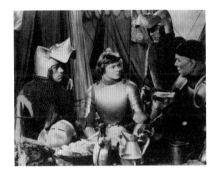

detail as a farmer's daughter. The director chose to demystify conventional film depictions of the heavenly host, so that when Joan communicates with her famous "voices," we neither see nor hear the angels. What is romanticized instead of the supernatural is, as in *Oz*, the rural countryside and the psychological experience of the lonely female adolescent—distinctly, if not deliberately, echoing *Oz*'s "Over the Rainbow" scene (which happens to have been directed not by Fleming but by King Vidor, so this can be considered homage rather than self-plagiarism). Joan's triumphal entry into Orléans in Fleming's version practically calls out for a chorus of "Ding-Dong, the Witch is Dead." Indeed, as Joan stands before the adoring peasants who consider her their savior, the camera shoots up at her to dwarf the extras—a tactic accomplished repeatedly by mounting Ingrid Bergman on a horse, or by sending her out to battle among throngs of kneeling soldiers who look like nothing so much as munchkins.

But it is really in their relation to particular male characters that a reciprocal influence is established between Joan and Dorothy. In Fleming's depiction, Joan's allies among the captains of the French army are arbitrarily narrowed down to three. Their armor, obviously, creates a reminiscence of the Tin Man; one of them, however, is clearly a Cowardly Lion; and the Duc d'Alençon, an historical figure, is restyled in the role of Dorothy's Scarecrow, the first and most faithful follower of the three (the actor playing the role even resembles Ray Bolger). When each of the three captains is given a separate send-off, there appears to be an overt borrowing

from the climax of *Oz*, sentimentalizing the relationship between girl and men in similar terms:

"Don't lose heart, Joan."

"If anything could make me lose heart, it's saying goodbye to you three."

As the Tin Man says in *Oz*, "Now I know I have a heart, because it's breaking." Ingrid Bergman, as Joan, seems to stop just short of saying, "I think I'll miss you most of all."

The figure of the Dauphin in Fleming's *Joan of Arc* echoes *Oz*'s Wizard, ineffectual and deficient in genuine authority; it is Joan who empowers the Dauphin by showing him his own weakness, as Dorothy liberates the Wizard by unmasking him. The message Joan brings him, a religious and political one in traditional legend, is reduced in the film to the banality of the ostensible moral of *The Wizard of Oz*: What you seek is within you, and true power derives from being true to yourself. Perhaps more significantly, this message doesn't save Joan herself any more than it helped Dorothy; it redeems only the men around her. The little girl from Kansas still requires magical aid to return home; and Joan, though she may have rescued the French monarchy, was still burned as a witch—a wicked witch, not a good one.

Why these stories of virginal female heroes and spectacularly inadequate men? The key may lie in just this linkage of motifs. Dorothy's three male comrades are, as everyone knows, defined by their respective deficiencies. The essentially anatomical flaws in the make-up of the Scarecrow and Tin Man reveal that the Cowardly Lion's more abstract shortcoming, his lack of courage, is a bowdlerization; as the Scarecrow and Tin Man are missing brains and heart, what the Lion is missing is *cojones*. The munchkins and, of course, the Wizard of Oz himself are similarly imperfect and incomplete. That Dorothy meets no real men at all on her quest cannot be the consequence of the conventions of fantasy; rather, it is their precondition, their reason for being. In both the films of *The Wizard of Oz* and *Joan of Arc* and the originating stories, the males encountered are deficient precisely because the object of the virtuous, virginal female hero's quest is a father figure, and the

fantasy mandates that she find no one on earth adequate to the role.

There is a style of traditional fairy-tale heroine, like Sleeping Beauty or Cinderella, who passively awaits her prince; and then there's another, like Joan and Dorothy, who is carried off on a quest that ends in disappointment. Archetypally, the ultimate model must be Persephone, who is dragged off into Hades—just as Lewis Carroll's Alice, another possible incarnation, is transported underground. Joan and Dorothy are more than the patron saints of runaway children, however. If the Persephone tale reflects the adjustment mothers and daughters must make to separation when the younger generation marries, the later stories, perhaps because they originate in patriarchal societies, concentrate on a fantasy of reunion between daughter and father, with no handsome prince in sight. Whether the fantasy is the daughter's or the father's must be judged according to who holds the power in the story.

Joseph Campbell's universal messages to the contrary notwithstanding, the quest does not turn out the same for girls as for boys. Dorothy's many virtues do not bring her to her bliss. Her return home may be a happy ending, but it's also a failure. She acknowledges the deficiencies of men by returning from over the rainbow to her accustomed place—even the all-powerful Oz is a humbug. Joan's God, who also fails her, is darker and angrier. He requires immolation in His name. In both cases, the aim of the story is to show the adventurous daughter—who cannot, unlike the traditional male hero, hope to supplant the father—that no other man can take his place. Yet another reason why, in popular literature, a good man is hard to find.

The Nature of Drag

JANUARY 1995 WHATEVER HAPPENED TO NATURE? Well, apparently it's
still out there. We know because once in a while we see it at the
movies. Recently we've learned that it looks especially striking with
a few drag queens artfully strewn here and there, like design accents
in a vast but sparsely furnished living room.

For this we have to thank *The Adventures of Priscilla, Queen
of the Desert*, the recent buddy flick—and then some—that follows
three lovable drag performers as they rehearse their act in the Aus-
tralian outback, on a long, improbable bus journey from Sydney to
Alice Springs. One way to consider *Priscilla* is as an exploration of
the two fortuitously linked senses of the word "camping." In the
film, at least, the conjunction of ideas is deliberate. You may recall
the scene in another cult odyssey, *My Own Private Idaho*, in which
River Phoenix declares his love for Keanu Reeves by a campfire in
the wilderness. This episode seems to have had a special appeal for
an awful lot of young people, straight and gay and all points in
between, and I think the simple reason is the refreshing juxtaposi-
tion, rarely encountered in popular culture, of the sexual outlaw
and the wide-open spaces (nothing new to you, of course, if you've
ever rented that *lurid* cowboys-and-Indians fantasy, *Song of the
Loon*). Transplanted from their native urban setting into the arms
of that tired old queen Mother Nature, gay hustlers and drag artists
seem to the straight world quaint and dear rather than exotic and
threatening. What *Priscilla* establishes is that homosexuals, trans-
sexuals, and transvestites are not naturally outside nature but belong
in it. They look *fabulous* there.

What is a drag queen? Think of Tony Curtis and Jack Lemmon in *Some Like It Hot*, pitching their hips from side to side as they totter along, perched atop stiletto heels. It's often held that Marilyn Monroe—with her cantilevered foundation garments, platinum cotton-candy hair, and bizarrely hyperfeminine affectations—outdrags them both. But Lemmon and Curtis (or their characters in the film) are, strictly speaking, merely in disguise, not in drag. Drag performers do not just pretend to be women. Like Marilyn, they pretend to be Woman—to incarnate the ideal rather than the particular instance. For drag to work, an audience must admit to harboring some shamefully incorrect image of femininity, and even to feeling nostalgia for this Woman who never existed in reality. More than that, they must accept seeing this ideal, once it is manifested, vulgarly satirized. No wonder so many people don't get it. No wonder, when it works, it's such a scream.

Drag is an extremely unstable form of irony, shifting meanings according to the differing sensibilities and sensitivities in its audience, and sensitivities are particularly tender when the joke is about sex. Drag disconcerts both the defenders and the revisers of tradition by confirming both positions. Sex roles must be

grounded in nature, or drag is not funny—yet they must also be mere conventions, or drag is not possible. *Priscilla* distills this issue in its very first image: a gossamer drag chantoosie named Mitzi lip-synchs the horrendous anti-feminist anthem "I've Never Been to Me." The spectacle of a cosmetically enhanced male dishing up this kind of kitsch—the complaint of a beautiful woman trapped by her glamour—is the most traditional of drag turns, depending for its comic impact on the belief that men and women differ by nature, and for its satirical edge on the embarrassing shallowness of that belief. This particular condition, as it happens, goes further, in an hysterical little recitative elided in this performance, perhaps because it states so precisely the theme to be explored and travestied throughout the rest of the film—that authentic identity is determined by sex, which is to say, nature: *"Y'know what truth is? It's that little baby you're holding, and it's that man you fought with this morning, the same one you're going to make love with tonight. That's Truth. That's Love."*

That, my dear, is Biology as Destiny. But the fact that, as we almost immediately learn, drag queen Mitzi himself is a failed and concerned father/mother suddenly gives the song thematic piquancy and richness. What is "natural" for women is either reinforced or subverted by seeing it enacted by a man, and it is hard to tell which. Perhaps both.

Enter (into increasingly more recent films) the transsexual, who represents the idea that well, yes, identity *is* determined by nature—but nature sometimes errs. A male transsexual knows himself to be a woman, not because he knows he likes to do what society says girls like—that would be mere effeminacy—but because he *feels like* a woman. He knows his nature to be womanly. But what is this feeling of womanliness like? I hope I speak for millions of not especially conflicted males when I say I am not sure what it feels like to feel like a man. At the movies, whatever may be the case in reality, womanly feelings in transsexual characters come down to social stereotypes—to assigning to male roles the kinds of aspirations and character strategies formerly occupied only by females, now suspect precisely because they appear to enslave women, not

to nature, but to an ideology about nature. Eventually, it seems, the only women we will see in the movies who believe themselves to be unfulfilled without children to care for or a big strong man to protect them will be male-to-female transsexuals, like Bernadette in *Priscilla*. (Those who believe in an essential *male* nature, and there seem to be plenty, might hold that the recent interest in male-to-female transsexuality and the whole fad for transvestism in films just show that men feel compelled to prove they can outdo women at everything, including playing at being earth mothers and coy virgins.)

Like *The Crying Game*, *Priscilla* supports the traditional values placed on the natural activities of mating and parenthood by extending their application, lifting the traditional restrictions upon the sex, or sexual orientation, of partners in the bond. This is a view which, thankfully, throws out the ancient idea of stigmatizing some natures as unnatural. But such films may actually use the image of transsexuality to avoid dealing forthrightly with male homosexuality. In *The Crying Game*, the general audience understands that transsexual Dil is really a woman *because* Fergus loves him; the plot is possible only because Fergus and the audience compensate for nature's error by recognizing Dil's *true* nature as a (kind of) female. It is impossible to imagine the film achieving anything like its unexpected success if, instead of turning upon Fergus' discovery that Dil is a girl who happens to be biologically male, it portrayed Fergus' discovery that he himself is by nature homosexual. The figure of the transsexual as honorary woman masks the figure of the homosexual as real man. (I'm waiting for *Crying Game II*: Released from prison, Fergus falls into bed with a long succession of alluring but increasingly obvious pre-op transsexuals, managing to look less and less convincingly "surprised" each time his latest lover reveals she's really a boy.)

Weirdly enough, *Priscilla* actually bears a deeper, more interesting resemblance to another surprisingly popular film on the espresso circuit, *The Piano*—though the latter is sadly devoid of either cross-dressed or transsexual characters. Let's see . . . if we substitute endless desert for endless mud; Australian Aboriginals

for New Zealand Maoris; throbbing, insistent, repetitive disco music for throbbing, insistent, repetitive Michael Nyman score; drag performance for piano virtuosity; and, well, of course, drag queens for women—Oh my God, they're the same movie! But what *The Piano* dresses in stiff, somber bombazine, *Priscilla* drapes with lamé and ostrich-feather boas and plays as parody: namely, the idea of a natural self, which Eurocentrically conceived characters in conventional epics, novels, and films discover by removing themselves from civilization. There's also the paradoxical contrast of an "old" and repressive world with a "new" and natural one; and the depiction of women and indigenous people as "in touch with nature," in a particularly grating popular phrase. For example, because in nature people must behave naturally, *The Piano* follows the tradition of stereotyping native peoples as unconflicted about sex, since they experience no distinction between a natural self and the rules society imposes—which is nothing more than a polite way of calling them savages. With the sensibility of the urban drag queen, *Priscilla* exposes the silliness of the ideology of liberation through a return to nature that *The Piano* treats with deadly seriousness. In effect, Ada's journey from uptight Scotland into the muddy land of the Maoris is just an extended illustration of the theory of psychological tourism *Priscilla* giggles over in "I've Never Been to Me."

What is a drag queen? Above all, a drag queen is an artist. The piano of *The Piano* is a means to an end, an outstanding example of art as therapy. For all the romance that swirls around the figure of Ada as she plays, her virtuosity is depicted solely as a response to the horrors society has imposed upon her, primarily through the institution of marriage. When she is finally brought to nature—to the discovery of her own nature—by really good sex, she no longer needs art; as though to reinforce the lesson, her cherished piano almost drowns her. We are used to accepting a simplistic opposition of art and nature in popular culture. But what if art is not just a sublimation or a substitution, compensating for nature thwarted or unfulfilled, but a spontaneous expression of impulses as natural as those toward mating, or seeking shelter or food? What if the birds sing because they are full of sorrow or joy, because it

feels good—or just because they *can*? What if art is not anomalous in nature but belongs there, like the putative anomalies of homosexuality or transsexualism—as drag queens, in all their glory, belong in the Australian outback?

If that is the case, then nature cannot compensate for art, either, and really great sex, or really great love, though they certainly may distract you, will never take the place of art, any more than art will take their place, or places. Drag queens have always understood this. Art is not just something you do till the right man comes along, after all. It is as much a part of your nature as sex is.

So you better *work*, girl.

The Gay Deceivers

⌊MAY 1993 AS IT HAS RECENTLY BECOME ABUNDANTLY CLEAR that the
Army doesn't really want you to be *all* that you can be, this may
be an opportune moment to look back at a much-maligned film
from 1969 called *The Gay Deceivers*, an odd little relic of a time when
the hot topic of the day was not the imposition upon gay soldiers
of a heterosexuality oath, but rather how to stay out of the army by
any means possible, including the pretense of homosexuality.

Released when the Vietnam War was at its height and "homo"
was a practically inevitable term of abuse among American males,
The Gay Deceivers (directed by Bruce Kessler, screenplay by Jerome
Wish, story by Abe Polsky and Gil Lasky) proposes the side-split-
ting spectacle of two regular guys engaged in a scheme to evade the
draft by representing themselves as a gay couple. Danny, the Good
Boy (Kevin Coughlin), has a blond stewardess girlfriend and a slot
awaiting him in the fall at Stanford Law School; his partner in de-
ception is Bad-Boy Elliot (Larry Casey), a lifeguard/gigolo—in fact,
the male equivalent of a blond stewardess, according to 1960s film
conventions. They represent the two poles, as it were, of thoroughly
convincing male heterosexuality: husband material and compulsive
pussy-hound. From the perspective of the 1990s, they seem to
define what is meant in those personal ads by the phrase "straight-
appearing."

To keep up their act, Danny and Elliot move into a gay-ghetto
apartment, furnished with a pink boudoir, plenty of homoerotic
tchotchkes, and a luxuriously round, red, enormous bed, which the
boys must share to divert the suspicion of draft-board spies. After

all, they have agreed to "live like homosexuals." At the time, camp was not a familiar feature of American film, and it was this aspect of *The Gay Deceivers*, including Michael Greer's outrageous perfor-mance as the boys' decorator and landlord—an attenuated Bette Davis impression—that won the film a small but elite gay following. The focus of the film, however, is really on the moral lesson of the boys' imposture. When word gets out that he is shacked up with a guy, Elliot is fired as a bad influence on the children at the pool; is called upon to prove his heterosexuality on demand by sleeping with his best friend's little sister but (to compound the hilarity) can't get it up; and undergoes the ultimate humiliation of putting the make on a drag queen in a bad Tricia Nixon wig whom he has mistaken, preposterously, for a real woman—leading to a scene that prefigures *The Crying Game* a generation earlier, and is far more amusing. For his part, Danny is rejected by his girlfriend, his father, and ultimately even the draft board, which refuses to accept his plea that the whole gay thing was just a hoax—a sad instance of The Boy Who Cried Fag.

It goes without saying that *The Gay Deceivers* is far from being a kind of *Gay Like Me*. The idea of heterosexuals coming to terms with the discrimination gay people face would not have occurred to Hollywood in 1969; it has barely begun to now. Neither is the film simply a closeted, nodding and winking camp farce. *The Gay Deceivers* is actually a buddy movie, fulfilling and criticizing the form a year before *Butch Cassidy and the Sundance Kid* made the genre official, and its real concern is with how even the pretense of homosexual romance destroys the friendship of two heterosexual men. Or the pretense, at least, of *gay* homosexual romance.

At the draft board, Danny—whose clever tactic is to pretend to be gay trying to pass as straight—dodges the question, "Have you ever had a homosexual experience?" by answering, "That depends on what you mean by *experience*." Actually, it depends more on what you mean by *homosexual*. A vexing and imprecise term at best, *homo-sexuality*, as it is commonly used, has left us without an unequivo-cal term for the culturally determined relations, other than sexual, of members of the same sex, gay or straight—including a version of

romance that is arguably more central to mainstream American values than either heterosexual or gay-homosexual romance. It's as if the terminology we use were conspiring to make the cultural hegemony of straight-homosexual romance invisible. Like all buddy movies, from Redford and Newman to Gibson and Glover, *The Gay Deceivers* presents an idealized vision of straight-homosexual romance—the chaste rituals of love between self-identified straight men that we sometimes call male bonding, which are, after all, what Plato meant by Platonic love. But it was also the first exemplar of the genre to treat, however farcically, the same issue that has the military establishment so exercised today: the perceived threat to the buddy relationship among straight men posed by an openly gay identity and culture.

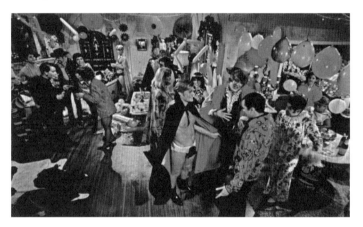

Openly gay homosexuality is deprecated by military culture because it threatens to ruin the assumptions that make intimacy, trust, mutual acceptance—in short, love—possible in the putatively straight-homosexual settings of shower rooms and pup tents. The camaraderie of these all-male milieus comprises what a semiotician might call the Buddy System, the cultural codes that control straight-homosexual romance in contradistinction to both heterosexual and gay-homosexual romance. One familiar and intriguing rule of straight-homosexual romance, for instance, allows men to speak of their love for one another as long as the masculinity of the love-

object is not avoided but emphasized: One never says "I love him," but "I love *the guy*"; never "I love you," but "I love you, *man*." A notorious (and thrilling) feature of straight-homosexual romance is to engage in mock gay-homosexual romance, including open flirtation and frequent reference to sexual practices and proclivities. (Thus, Oliver North claims not that "Reagan loves me," but that "Reagan loves *my ass*.") The obvious inference, as the character Danny in *The Gay Deceivers* well understands, is that anyone who actually was gay would be pretending not to be, so that anyone who pretends to be must not be. But the joke must be managed within strict limits, or it comes to seem truly queer.

The point of the "ban" on gays in the military—which everyone but the most naïve of elected representatives recognizes is no ban at all—is not to exclude persons, but to ward off an idea. It is a hopeless, anachronistic attempt to preserve straight-homosexual romance by declaring gay-homosexual romance unthinkable. After all, that is what the codes of straight-homosexual romance require—even when actual homosexual sex is going on, apparently. Regulations in all branches of the military recognize that straight men will sometimes have sex with each other and allow some leniency in retaining heterosexuals who engage in homosexual sex, while requiring the discharge of open homosexuals even if they never engage in sex. The simple reason for this official discrimination is that the codes of gay homosexuality confuse the codes of straight homosexuality, the rules of friendship among heterosexual males—a cultural province that is perceived as even more beleaguered than the other great bastion of institutional heterosexuality, The Family.

The Gay Deceivers responds to the gay-homosexual threat to straight-homosexual romance ambiguously, by mixing tragic—or at least melodramatic—and farcical elements. The tension between the two gives the film such depth and interest as it has. The commonplace notion that partners in crime turn on each other, destroying the buddy-bond, lends *The Gay Deceivers* its musty and phony air of moral fiction. But because the boys, once they prove to be less than fully dependable to each other, fight like jealous lovers, straight

and gay homosexual romance are used to satirize each other. Elliot
and Danny have their first serious spat—as they're about to get
chastely into bed together—because Elliot is planning some hetero-
sexual hanky-panky that Danny fears will be detected and give
away the game. Certainly, this is a sly indication of gay homosexu-
ality lurking, in the form of exaggerated jealousy, under the surface
of straight homosexuality. And yet the obviously irrational insis-
tence that any contact whatsoever with women will compromise
their pose really seems less like a gay-homosexual theme than a
straight-homosexual fantasy: To find anything in reality approach-
ing this fetishistic avoidance of women, one must look not to gay
life—even in the '60s—but to the ostensibly superstraight-homosex-
ual cults of sports teams, fraternities, and military barracks.

The farcical treatment of draft evasion in the film also amounts
to an admission that anyone, however unimpeachably heterosexu-
ally inclined, might pretend to be gay if it meant staying out of the
war. Yet *The Gay Deceivers* still insists upon its exemplary warning
that the pose of homosexuality, transported out of its context of
locker-room humor, dangerously compromises straight masculinity
in itself. The cult of straight-homosexual love is also a cult of
aggression, a fact that appears a little less obvious today when the
armed services are being promoted as a kind of combat-ready Job
Corps, but which is abundantly evident even in such peacetime
film treatments of straight-buddy love as *Top Gun* and the *Lethal
Weapon* series. By the rules of the cult, the boys in *The Gay Deceivers*
deserve to be stigmatized as though they were gay-homosexual
faggots for being cowardly enough to pretend to be.

Perhaps even more importantly, Elliot and Danny's mock
tragedy is, finally, that they're not homosexual *enough* for the army.
Unlike the conventional heroes of the purest of buddy movies,
they've allowed women to come between them; their friendship
falls apart—even as they are left, ironically, stigmatized as gay
lovers—because they're not really cut out for straight-homosexual
romance. They fail as members of the He-Man Woman-Haters'
Club. A final sort of punchline to the whole film acknowledges this
by catching the military officers at the draft board in a casual and

awkward caress, revealing that they've kept the boys out because their gay act has shown them to be all too heterosexually inclined: "*We don't want their kind in the army, do we?*" The fake gays' fake desire to get into the army to consort with all those yummy men turns out to be the real motivation of the fake straight officers. Is this a real-gay joke, dishing Miss Thing in her tired butch army drag, or a mock-gay joke, like ostentatiously dropping the soap in the barracks showers? Even in 1969, it was evident that no one can count upon drawing a stable, clear line between the two, and that may be what has the military establishment so nervous right now.

One Man's Meat

MARCH 1994 SOME TWENTY YEARS AGO, Boyd McDonald began pub-
lishing out of his apartment a journal of men's true, prodigiously
explicit accounts of homosexual sex, entitled *Straight to Hell*—
a.k.a. *The Manhattan Review of Unnatural Acts*, a.k.a. *The New
York Review of Cocksucking*, and later—amid an alphabet soup of
mainstream publications like GQ, W, and HG—archly and elegantly
styled *S.T.H.* Eventually, McDonald, who died in 1993 at the age of
68, edited the anonymous autobiographical letters to *S.T.H.* into
more than a dozen books with titles such as *Meat*, *Filth*, *Flesh*, and
Raunch. All were best-sellers at gay bookstores, somewhat to the
embarrassment of earnest gay literati.

The essential democracy of the project is inspiring: Every
man becomes his own Henry Miller, every sexualist is his own
Jean-Jacques Rousseau. It is conventional to claim that smut makes
weary reading, but the autobiographical accounts in *S.T.H.* are
sprightly, involving, full of intense interest and detail, and offered
without the tiresome self-justification of most writing at the margins
of society. In contrast to most contemporary fiction, the memoirs
in these collections are precise in their aims and entirely without
affectation in their style. McDonald developed a distinctive manner
of titling his contributors' stories to parody news items, so tren-
chantly that the editor's statement is made even before the author
begins to speak: "Baptist Boys Do It, As It Were, In Church";
"Typical 'Straight' Admits Weakness for Friend's Tongue"; "Youth
Leaves Damp Underpants for Host to Sniff"; "The Love That
Dare Not Speak Its Name: Armpit-Sniffing."

These reminiscences are news that stays news. McDonald insisted that what he printed was not pornography, which for him meant the trite, self-conscious fantasies generated by guilt and timidity that were increasingly available in the 1970s and '80s through an increasingly commercial salacious press. He published The Truth, in the manner of a crusading journalist—a photographer without a camera—with the serious intention of assembling documentation of homosexual sex in its "classical" age, 1940-1980. The result is a kind of oral (as well as anal and genital) history, taking the reader into terrain at once strange and familiar: the unacknowledged corners of life where repression is not lifted, but exploded to bits. In contrast to pornographic fantasy, the meaning of every scene, scent, and sensation McDonald placed before his eager public is simply that, however American life has been represented in the official organs backed by business, state, and religion, such things actually do happen.

In effect, McDonald was not only a documentarian, but one of the great satirists of the age, if a satirist primarily by proxy. The needs and products of the body horrified Swift and disgusted Orwell; even to William Burroughs, they are a dark rather than joyful secret. But McDonald saw them as literally the essence of life, betrayed by the hypocrisy and pretensions of a society in which men are trained to seek power and reject love. The emblem of his stance is an illustration he once used in *s.t.h.*: a male nude with the caption, "I'm not just a human being, I'm a piece of meat." Through the sheer abundance of true stories, McDonald presents a picture of homosexual sex as a nearly universal male experience, in pointed contrast to the contemporary ideology of homosexuality as special identity. In the world of the *s.t.h.* books, every barracks shower is an orgy room; every Boy Scout jamboree is a festival of sexual initiation; every conservative politician and clergyman pays male hustlers for sex. Everything men do to bond or compete in sports, war, and politics is a sublimation of, if not a substitute for, homosexual desire.

Just as the cutting-off point of the classical period at the start of the age of AIDS is no accident, neither is the writers' intention of

getting the reader hot and bothered—providing, like phone sex and porn flicks, an alternative to the risks of in-person sex. This may help to explain what separates the *s.t.h.* books from the common run of heterosexual pornographic fantasy: not so much the obvious difference in subject matter and object of desire as the relation they establish between writer and reader. The relentless popular discussions of hetero porn lately focus on an imaginary relation, one between the consumer and the person—the woman—portrayed as a sexual object. The actual relation of the real partners in the pornographic communication—the sender and the receiver, the producer

and the consumer—is generally ignored. It is for this reason that verbal and pictorial porn can be treated as functionally equivalent by advocates of censorship (as well as by free-speech advocates), when what really transpires in the two cases is so manifestly different. What we see in the war against pornography is an effort to slap the naughty consumer's hand (the one he has free) and make him drop the manufactured fantasy before it warps his mind and stunts his growth. But the whole point of pornographic communication is that masturbation becomes no longer a solitary vice; the consumer of pornography is, in reality, never truly alone with his fantasies and his fist.

Hetero porn is produced almost exclusively for men, and almost as exclusively *by* men. It is rarely, in actuality, a matter of women getting men hot, but of men getting men hot—by telling dirty stories about women, or presenting dirty pictures of women. Thus, the prudes are partly right to say that porn is essentially adolescent; its system of production and consumption is one great circle jerk. What they fail to recognize, however, is that this homosexual circle endures in adulthood not as a kind of arrested development, but as a perfectly ordinary factor in heterosexual response—as evidenced by the way that male mammals of any species are aroused by each other's arousal, or by the bewildering emphasis on the "money shot" in pornographic films produced for the straight male consumer. (I have only recently learned that there are phone-sex lines on which straight men can swap heterosexual sex stories while they jack off; to a gay man, this seems not only titillating but truly *queer*.) The very real homosexual component in heterosexual relations is impossible to separate out, and the fantasy relation to a sexual object in verbal pornographic communication among men conceals an actual homosexual relation, mediated by the printed word. But that relation may never, ever be acknowledged.

It is at least possible that the notorious aggression towards women in heterosexual porn, far from being an entirely contextless display of men's violent fantasies about women, results from the repressed homosexual situation of heterosexual porn. It may be a matter of self-presentation in the homosexual circle, reflecting how

both the producer and consumer want to be perceived by other men—especially in the intimate and vulnerable conditions of the pornographic communication. (This is not to say that this style of pornography doesn't inspire men to degrade women and commit rape; I don't see how anyone, however committed to freedom of expression, can deny that it does.) The emphasis on domination in heterosexual pornography is a whining attempt to find love—but the love of other men, the real partners in the sexualized relation of pornography, and not that of the imaginary subject of fantasy. In the first-person accounts of the *s.t.h.* books, the homosexuality of the writer-reader relation is openly acknowledged as the whole point of the communication.

McDonald said that his mission was to replace pornography with *smut*—by which he meant talk about sex that is truthful, idiosyncratic, and honest even about its own reason for being. Contemporary crusades against pornography focus single-mindedly on the eradication of certain kinds of representation that are deemed dangerous influences on attitudes and behavior. They may well be; but to argue for repression is to neglect that in any struggle over ideas, falsehoods and fantasies do not yield to a determined silence, but to truth. For that reason, what we need is not a moratorium on any one kind of imagery or speech. What we need is more smut.

Soul Party

FOR WHATEVER REASONS—mercenary ones foremost, undoubtedly—a remarkable number of fantasies on the theme of personal identity have been appearing in popular film over the past few years. Plot devices such as reincarnation or time travel appeal to a magical conception of identity as alienable from the body, stable even through the passage of centuries. Characters who move through a recognizably human world as robots, computer simulations, or cartoons question that magical conception of the ineffable, intangible human essence—the soul. So many recent films turn on the problem of personal identity that, even if they depend heavily on earlier examples for their basic conventions, they may constitute an unrecognized genre, one rooted in a national agony over the nature of selfhood in the 1980s. These are not, in the account of any serious critic no matter how trendy or depraved, among the major *oeuvres* of the period. But the very triteness of their conceptions of sex, love, age, learning, and labor testifies to their value as documents of popular belief.

A prime example of the tendency is the presumably fortuitous release during 1988 of two fantasies of father-son soul exchange: *Like Father Like Son* and *Vice Versa*. (Evidently, the people who write movie titles have much the same view of punctuation as Gertrude Stein. But there the resemblance ends. Stein wrote, famously, "I am I because my little dog knows me," and such an outer-directed account of selfhood is conspicuously missing from these films.) In the former, soul transfer is effected by a Native-American (apparently Navajo) ritual; in the latter, via a weird Buddhist skull-thingy smuggled from Thailand—evidence that

xenophobia as plot device has not advanced much since the idol's-eye thefts of nineteenth-century British fiction. But while in *Vice Versa*, actors Judge Reinhold and Fred Savage indicate to the audience that soul transfer has occurred by launching into creditable imitations of each other, Dudley Moore and Kirk Cameron in the much cheesier *Like Father* impersonate generic versions of adolescence and adulthood, neither bothering to adopt any of the other's mannerisms—not even their distinctive accents. This evident lapse is especially noteworthy because in the prologue establishing the possibility of soul transfer, two previous transferees

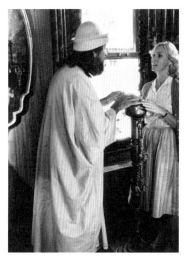

switch languages, as we would intuitively expect. *Vice Versa* does not problematize the transfer of selfhood as memory and knowledge in any way, but *Like Father* implausibly proposes that while language is acquired knowledge, idiolect must be due to the biological endowment that does not change with soul transfer— to the "vessel."

One is tempted to conclude that the actors were just not up to the task, but even if *Like Father* is the less competent of the two films, it is at least on this issue the more interesting. These obvious flaws in the film's conception of soul exchange seem more like parapraxes, meaningful slip-ups that lead from the manifest supernaturalist fantasy to the latent fantasy both films share, which in turn depends upon an insistently Oedipal conception of selfhood. In *Vice Versa*, both father and son are adjusting to divorce; soul transfer is their imaginative means of resolving mutual resentment and hostility. In *Like Father*, however, though Dudley Moore has not given up grieving over his wife's death several months before, his son appears unaffected by the loss of his mother. This suggests that the soul exchange signifies for the boy an identification with his father triggered by denial and resentment, and for the father the release of a submerged

desire to live his life over again from puberty without the woman who would ultimately disappoint him by dying. *Vice Versa* represents a simple wish fulfillment for both partners in the exchange of souls, but *Like Father* advertises its inept conception of the soul-exchange convention as if to reveal the *folie à deux* of parent and child, each playing at the other's role in an attempt to compensate for the mother's death.

It is clear that soul transfer, like certain ancient initiation rites it resembles, is conceived as a very male affair. A much more successful film of the same year, *Big*, harps on the same hackneyed, superficial message as do our other examples—that we would all be more *attractive* if we retained our childlike sense of wonder—but without the device of soul transfer. Instead, its protagonist Josh Baskin, as played by Tom Hanks, grows up physically while retaining his identity as a child. As in the soul-transfer plots, the mere fact that this conceit makes any sense to us at all says as much about the social roles of adult and child as about any metaphysical concept of self; the unremitting masculinity of the conception of selfhood remains the same. The title of the film itself is an open Freudian joke. In fact, a celebrated moment in *Big* is exactly replicated in *Vice Versa*, predictably and undoubtedly coincidentally. In each film, the adult actor is called upon to display the prepubescent boy's delight at discovering he suddenly has a grown-up's genitalia. Furthermore—you Lacanians out there will love this—in both films, the boy-as-man realizes and confirms his new bodily identity by gazing at himself in a mirror. The mirror is employed as a device to show the actor's reaction to the audience, and invite their identification with the character's emotion; but the character in both cases gazes down at his new penis directly, on his own new body, and not at its image—as though to confirm the integration of the mirror-image with his conception of self.

The conjunction of these metaphysical fantasies dramatically displays the problem they are all responding to: not merely the body-mind dualism inherent in our traditional conception of personal identity, nor simply the relation of biological endowment to acquired behavior and knowledge in the construction of the self,

but specifically the question of the identification with the father's penis-as-self in an age in which father-son relations are considered too distant, and models of masculinity too problematic, to result in successful continuity of values and tradition. After all, these films posit identification of father and son as a fantasy, not a reality.

Furthermore, these popular fantasies recognize that the penis-as-self model is loaded with uncomfortable contemporary issues while playing them for comedy. What might be called the "Scene of the Penis" appears with a different spin in *Innerspace* (1987), in which combat pilot Tuck Pendleton (Dennis Quaid) has been miniaturized and injected, inadvertently, into the body of wimpy Jack Putter (Martin Short). Not much energy is wasted in explaining how selfhood is maintained through this *Fantastic Voyage*-style transformation; the fantasy centers on Putter's intro-jection of Pendleton, not the integrity of Pendleton's self. Something far more psychosexual is going on, as is apparent from the fact that hunky Pendleton is injected into pliant, passive Putter's but-tocks, in a version of soul transfer that takes up the homoerotic context ignored among the generational conflicts of *Vice Versa*, *Like Father*, and *Big*. The subtext of the comedy throughout *Innerspace* (as in so many of the buddy films of the '80s) is that when homo-sexual anxiety is present, it is impossible to confirm masculinity without threatening it; the male bond is at the core of the conception of self, but it can be overtly acknowledged only within strictly de-fined, socially mandated limitations. In a men's-room scene, Putter looks down as he urinates, and Pendleton gazes through his eyes from inside; as the two converse within one body, a gentleman passing by says in exaggerated dismay, "Don't talk to it, son." The gag, which seems to convulse audiences, explicitly identifies the heroic Pendleton (whose name suggests pendulous) with the penis as well as the self of Putter (whose name suggests Putter), as a hypermasculine alter ego, the self as buddy, abstracted from the putatively heroic qualities of the penis—strength, aggressiveness, perseverance, indomitability—and internalized as selfhood.

This joke becomes the entire premise of *Me & Him* (1989), an American film adapted by German director Doris Dörrie from

a novel by Alberto Moravia (of all people). A man's penis talks to him. The End. This is perhaps the ultimate case of the male self as double, as split rather than exchanged or merged selves. Though the comedy is entirely predictable from beginning to end, it is interesting to note that Griffin Dunne, as Bert Uttanzi, rids himself of his noisome member only by taking a picture of it, studying the photo carefully, and then burning it—a kind of abreaction in which the second self is given another symbolic form so that it can be reinternalized. When the character finds he needs his penis again—I am not making this up—he is able to resurrect it by flashing, displaying it to another person.

So thoroughly do we accept the conventions governing the representation of sex in cinema that we may easily overlook an obvious pattern in all these films: The penis itself is never shown to the audience, even when a character's looking at his own/father's penis becomes a decisive moment in the establishment of a self. The penis remains the final frontier not only of selfhood as such, but of its privacy and ineffability. It may occupy the center of the plot as long as it is never directly represented; it may be the focus of elaborate jokes as long as it is referred to only by a pronoun. In recent American films, outside the non-genre of pornography, characters seek sex constantly and single-mindedly, consider sexual relations revitalizing (and apparently redemptive), and engage in sex as often as they can manage—but all without sexual organs. This alone suggests a deep and repressed connection between our notions of selfhood and the recent hysteria over the photographic representation of male sexual organs in art. Perhaps at a deep level, it is really imagined, as is alleged of many traditional peoples' beliefs about the soul, that taking pictures of penises will cause them, like Bert Uttanzi's, to disappear.

According to all these accounts, the self is deeply gendered. We would imagine, on the same assumptions, that a man's self transferred into a woman's body would remain male, as happens to another character at the end of *Vice Versa*, and in the classic tradition of soul-transfer films represented by *Goodbye Charlie* (1964) and *Turnabout* (1940). It is no news that this is the intuitive view in

our society, but it has nothing but intuition to argue for it—even our accounts of the phenomenon of transsexuality, for example, rest upon a simplistic, extremely dubious metaphysics of self. Just about the only elaborated film fantasy that takes this issue seriously is Carl Reiner's *All of Me* (1984), in which a female soul (played by Lily Tomlin) temporarily shares the body of a man (played by Steve Martin). The duality, and the need for coöperation it compels, is reminiscent of the situation in *Innerspace*, but the ideal portrayed is androgynous rather than phallic. Again, the realization of the soul transfer takes place in a scene constructed around mirrors— Tomlin's character can be seen only as a reflection—and in a men's room: The male and female selves control the lateral halves of the body, so the grudging collaboration of the female self is needed in order for the male self to fish his (their?) penis out of his fly and urinate. One of the great cinematic celebrations of heterosexuality in its period, *All of Me* should be especially beloved of Jungians, not only because it posits masculinity and femininity as essences anterior to biology and basically unaffected by it, but because of its depiction of a man's soul as his *anima*, or feminine ideal. But it is clearly the exception to the rule among soul-exchange plots.

The radical gendering of selfhood in these films, considered as a reactionary response to the threats of gay liberation and changing roles for the sexes, may have more in common with the themes of other metaphysical fantasies of the period than their superficial differences of story would indicate. The time-travel fantasy *Back to the Future* (1985) sends the unaltered personal identity of Marty McFly (Michael J. Fox) back through time instead of transferring it into another, coeval body, but the Oedipal thrust remains the same: The character must head off his mother's crush on him and promote his father's suit to ensure that he himself is brought into being. More importantly, the film portrays the impossible and horrifying Reagan-era project of turning back the hands of time to somewhere in the supposedly idyllic 1950s. Other (and better) time-travel films such as *Star Trek IV* (1986) and *Bill and Ted's Excellent Adventure* (1989) propose a more complex view of history, in which characters look both backward and forward in time to redeem the present

moment. But reincarnation fantasies such as *Made in Heaven* (1987), *Hello Again* (1988), and *Always* (1989) are so insistently derivative of earlier Hollywood genre films, so drenched in cheap nostalgia, that they betray their use of the notion of survival of personal identity after death as a kind of romantic protest against historical change.

The same themes expressed in these films run through the whole of consumer culture. The New Age enthusiasm for channeling, reincarnation, and astral projection that provides the exotic background for many of the silliest of these films testifies to a popular attempt to revise definitions of personal identity, as does the interest in books like Oliver Sacks' *The Man Who Mistook His Wife for a Hat* and Daniel Keyes' *The Minds of Billy Milligan*. These books offer empirical (and reputable) challenges to traditional no-

tions of the unity and autonomy of the self, much as Freud's best-sellers shook up the popular psychology of his own period in response to social change. Surely the concern for redefining selfhood, in religious or scientific terms, is not unrelated to our having had an actor for President for eight years, and to the radical anxiety that must be evoked by the increasing exploitation of the self as commercial product: the domination of political life by personal-image marketing; the reality issues of docudrama and infotainment; the whole self industry epitomized by the spiritual fervor surrounding health clubs, diet centers, tummy tucks, breast implants, and self-help books. If the 1970s were the Me Decade, the 1980s were the Self Decade, transforming the merely instrumental service of ego into a complex, obsessive national agony aimed at revitalizing (or perverting beyond recognition) traditional notions of personal identity in all its forms: soul, spirit, self. Most notoriously, the concern for declaring definitively, through legislation or judicial decision, when human life begins and ends—which has dominated

political agendas without resulting in any notable contributions to serious thought on the issue of what constitutes a person—betokens a society struggling impotently to formulate an authoritative response to the diversification of accounts of selfhood in popular belief. Seen in this light, the metaphysical fantasies of the film of the period are the dreams of a nation helplessly fascinated by that urgent diversity, as the bombing of abortion clinics and the protracted, publicized lawsuits over the rights of brain-dead persons or surrogate mothers are its nightmares.

Pee-wee's Plaything

NOVEMBER 1991 [*Scene: Interior of the Playhouse. Pee-wee packing toys.*]

PEE-WEE: Hi, boys and girls! Well, I'm packing up the Playhouse. So for one last time, let's see if Conky knows today's secret word! [*Does Conky bit: stiff-legged stomp, eyes rolling, arms flailing. Reads print-out.*] Today's secret word is . . . myself! You all remember what to do when you hear the secret word, don't you?

GLOBEY, FLOORY, CHAIRY, ETC. [*screaming*]: Scream!

PEE-WEE: That's right! For the rest of the day, whenever anyone says the secret word, scream real loud! Let's try it out on Randy! [*Looking up.*] Hey, Randy!

RANDY [*descending*]: Dat's my name, don't wear it—

PEE-WEE: Yeah, whatever. Whatcha doin' up there?

RANDY: I was playin' wit' myself! [*All scream.*] Dat stupid secret woid! Functioning as I do as a kind of Jungian shadow into which you project your proscribed anti-social desirings, I find myself condemned to remain eternally in the wrong, never growing or learning. But who pulls my strings?

PEE-WEE: Knock it off, Randy!

RANDY: Hey, Pee-wee! You ever seen a woodpecker? I've got twelve inches, but I don't use it as a rule. As Charles Ludlam would say. [*As he flies upward.*] We live our lives within quotation marks. It is the price of puppethood.

PEE-WEE [*Rolls his eyes.*]: Randy's *real deep*! Here comes Cowboy Curtis! [*He enters.*] Hey, Cowboy Curtis, what's today's secret word?

COWBOY CURTIS: Shucks, Ah don't know, Pee-wee. Ah jist got here mahself! [*All scream.*] Gawsh, Ah shore am gonna miss that secret word. And Ah'm turrible sorry yo're a-hangin' up yore spurs, little buddy. 'Specially since we never quite got around to Saturday morning TV's first interracial homosexual kiss. [*The Cowntess appears at the window.*]

COWNTESS: Moo-hoo, Pee-wee! Helloooo, Cowboy Curtis! Come to say your good-byes? I had the same idea myself! [*All scream.*] Oh, Pee-wee! These quintessential disjunctions that impede forward progress of the ostensible narrative line, subverting the established conventions of centrality of plot! Yours was the first popular television show to build self-consciously on the anti-traditions of installation and performance art, while boldly exploring the inherent qualities of televisual form itself. You know, Cowboy Curtis, I was wondering if you might enlighten me about something—I understand you are what they call a *cowpoke* . . . ?

COWBOY CURTIS: Ah reckon Ah'd be raght glad to explain, ma'am. [*He hops over the dutch door; they go off together.*]

PEE-WEE: What's going on here? Everybody seems to understand my show better than I understand it myself. [*All scream. Miss Yvonne enters carrying a stack of huge books, oversized glasses perched on her nose.*] Miss Yvonne! What's all this?

MISS YVONNE: Hi, Pee-wee! I've been improving myself! [*All scream.*] Really, Pee-wee, I just love contemporary criticism!

PEE-WEE: Then why doncha marry it?

MISS YVONNE: Gee, Pee-wee, I'm not sure it's really interested in girls like me! Actually, I've been reading all about *you*! For example, did you know that, writing in *Camera Obscura*, Ian Balfour says that: "A principal effect of Pee-wee's histrionics, whatever the outcome of the episode, is to unsettle culturally codified notions of masculine and feminine, indeed to twist them around."

PEE-WEE: Oh.

MISS YVONNE: And in the same issue, Constance Penley notes that: "The Playhouse's dizzying presentation of difference, accompanied by a constant plea for tolerance, shows a sharp understanding of how one might go about reordering (attitudes toward) difference, even under the gaze of the masters of the television universe." Parentheses hers, of course. Isn't that great, Pee-wee? Although I

 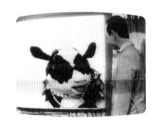

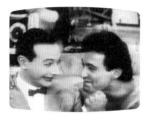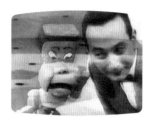

must say that in their commendable enthusiasm for the show's encouragement of diverse forms of transgression, even these enlightened critics avoid the problematic side of characters who perpetuate noxious stereotypes, ostensibly for the purpose of parody—such as, notoriously, myself. [*All scream.*]

PEE-WEE [*flailing*]: AAAAGH!

MISS YVONNE: You can stop screaming now, Pee-wee. [*But he continues.*] Why, Pee-wee, what's the matter?

PEE-WEE: I don't understand what you're talking about! I don't understand what *anybody's* talking about! I'm just a little boy! I wish I was smart enough—

JAMBI [*appearing*]: Wish? Did somebody say *wish*?

PEE-WEE: Jambi! I was just saying—

JAMBI: Skip it, I get the picture. Pee-wee, your problem is that, having entered the commercial world of television and adopted the persona of a child, you are doubly barred from the hermeneutic discourse of high art. In your own eyes, you are no more than a polymorphously perverse naïf.

PEE-WEE [*helplessly*]: I know you are, but what am I?

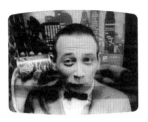

JAMBI: Pee-wee, where I come from, there are lots of men, boys, and even girls who lead smart discussions deconstructing the work of artists like you, and they don't know anything more about meta-physics, narratology, or political economy than you do. But they have one thing you don't.

PEE-WEE: What's that?

JAMBI: Graduate degrees in fields related to semiotics. [*Mortar-board replaces turban on Jambi's head.*] So, Pee-wee, on behalf of the University of Puppetland, Imaginary Studies Division, I hereby award you this degree of Doctor of Letters in Metal-eckahiniology, *honoris causa*, fer sher, dewd. [*Produces and confers degree.*]

PEE-WEE: I feel smart!

JAMBI: So, Dr. Pee-wee, have you seen *Paris is Burning*? Don't you construe this Playhouse itself as an instance of the phenomenon that that film documents among certain disenfranchised popula-tions in New York—the live characters here performing their own version of voguing, if voguing's essential thrust is to hurl stereotypes back into the face of the cultural hegemony? You would be the House Mother, of course, with Tito the lifeguard and his successor Ricardo the soccer player re-presenting the dark homosexual

desire-objects of the nominally super-heterosexual cult of mascu-
line athletics/aesthetics.

PEE-WEE: Of course! I understand it all now! [*Growing thoughtful.*]
And yet, even as I comprehend the Playhouse as self-consuming
satire, I wonder about my own character—you know, the whole
Pinocchio thing. I still don't feel I entirely understand myself. [*All
scream.*]

MISS YVONNE: That's because for all your learning, you're not real
introspective, Pee-wee! What you need is some psychoanalytic
therapy! [*Tiny round woman in tweed enters.*] And here's Dr.
Dinglefinger to help!

PEE-WEE: But she's short and fat!

MISS YVONNE: Short, fat people can be just as intuitive and theo-
retically grounded as tall, thin people, Pee-wee! You're smart
enough to know that! And what's more, she's really dogmatic!

PEE-WEE: OK, I'll try it!

[*Cut to Pee-wee reclining on couch, Dr. Dinglefinger seated behind
him with outsized pad and pencil.*]

PEE-WEE: So it seems that everything in the Playhouse ultimately
signifies the child's own circumscribed phallus, and that when I
play with Pterri or Chairy or Magic Screen, I'm really playing with
myself. [*All scream.*]

DR. DINGLEFINGER: Dot's rrrright, Pee-vee. You see, zese lively
personifications of inanimate objects represent ze growing child's
assertion of mastery over his own functions in defiance of ze par-
ents' control over his body as such—vitness toilet training und ze

prohibition, of course, upon masturbation—so zat ze Playhouse constitutes an imaginal reordering of autonomous regions of desire in your putatively pre-pubescent body into an ego-syntonic whole.

PEE-WEE: Duh! Tell me something I *don't* know! It's just that all this phallicism seems to leave out the little girls in our audience.

DR. DINGLEFINGER: It's *your* show, Pee-vee. As Freud vould say—

PEE-WEE: Yeah, that's swell, Dr. Dinglefinger, but we're out of time. Another interminable analysis, *nicht wahr?* [*Getting his bike.*] Well, boys and girls, I guess Dr. Dinglefinger helped me learn a lot about myself. [*All scream. Pee-wee adopts his histrionic manner.*] Yes, I am all the characters in my Playhouse, as you are all the characters in yours. That is, if you subscribe to the auteurist fiction that sees such complexly collaborative forms as television programs as the product, *au fond*, of a single originating consciousness. And yet I wonder . . . I wonder if the Playhouse's anarchic counter-strategies were not more effective, its ironies more delicious, its problematization of consumer culture's focus upon the body of the unsuspecting child more deliriously subversive before the intervention of these reductionistic analytic schemes . . . *before I exposed myself.* [*All scream, as Pee-wee zooms out of the Playhouse and rides off . . . forever.*]

Jason Voorhees, R. I. P.

SEPTEMBER 1991 AMONG SERIOUS STUDENTS OF HORROR, the *Friday the 13th* films are usually dismissed as decadent commercial dreck, unworthy of the tradition that gave us F.W. Murnau's *Nosferatu*, James Whale's *Bride of Frankenstein*, and Tod Browning's *Freaks*. Nine mind-blowingly violent movies in all, the series is commonly disparaged as a mere set of exercises in brutality, pandering to the stereotyped adolescent male, who is these days desensitized to the imagery of the abattoir. If, as Harlan Ellison says, television is chewing gum for the eyes, then the *Friday the 13th* series is chewing gum with a body count.

It is true that the psycho-massacre films of the 1980s—and there were plenty of them—do not compare favorably to such complex classics as *Dr. Jekyll and Mr. Hyde*, or even *The Wolf Man*. But the *Friday the 13th* series represents a new, hybridized form, derived less from the gothic terror of *Frankenstein* than from the nightmare of disgust in *One Hundred and Twenty Days of Sodom*. Compared to Sade's elaborately detailed permutations of torture and abasement, the contemporary bogeyman Jason Voorhees seems almost wholesome. Let us say that where Sade is obsessive, Jason is merely compulsive. All he wants to do is *kill* people, after all, and he doesn't seem to derive much pleasure even from that.

Jason has earned, or at any rate gotten, a place in contemporary folklore independent of the films that created him—a rare achievement in commercial culture, matched only by classic characters like Dracula and Frankenstein—or more recent figures like Kirk and Spock, and Barbie and Ken. In Jason's particular niche

(perhaps it should be called a vocation), only Freddy Krueger of the *Nightmare on Elm Street* series can be considered a rival (though of course Jason himself is the unacknowledged spawn of old Leatherface, that spirited cut-up in *The Texas Chainsaw Massacre*). Clearly, the appeal of the character and his exploits, such as they are, cannot depend on their structure of incidents, which is as formulaic as Sade's. On and on the action plods, as in most splatter horror, from victim to hapless victim; the sole suspense rests on who will next be served a steaming hot death, and in what grisly form. The choreographers of these psycho-murders (and of car crashes and conflagrations—the Busby Berkeleys of our time) have their own fanatical admirers, but relatively few viewers have so cultivated an appreciation of Grand Guignol technique as to sustain their devotion to the films on purely aesthetic grounds. There must be some other explanation for Jason's endurance, not to mention his box-office receipts.

For one thing, the series has the perfect title, even if the concept it invokes is used sparingly and subtly in the films. *Halloween* set the precedent for a slew of slasher flicks, including *My Bloody Valentine*, *New Year's Evil*, and of course *Silent Night, Deadly Night*, all of which appeal to archetypal memories of the dear old days when every calendric ritual was, allegedly, a cannibal feast. But only the *Friday the 13th* movies exploit the creepy, insistent aura of actual superstition, surviving to throw the occasional, flickering scare into the most rational souls. (Only *Don't Look in the Basement* provides a more powerful focus for the audience's longing to be scared shitless.) The summer-camp setting of the films recalls spooky tales told by the campfire, and their inevitable association of sex with violence (or of violence with sex?). Jason attacks his teenage victims before, during, and after the sex act—theirs, always, never his, which may explain the whole business in a nutshell. This convention, established in bad monster movies of the drive-in era, not only allows the audience a satisfying display of nubile flesh in all flavors, but frames the whole endeavor as a kind of hackneyed cautionary tale, reminiscent, in a grotesque way, of Hillaire Belloc's verse for children.

But despite their reputation, as a whole the movies in the *Friday the 13th* series are significantly more concerned with family relations than with sexual relations—which is what you might expect from films geared almost exclusively toward the age range when, despite whatever hormones may be raging, one's most desperate struggle is to create an autonomous identity outside of parental control. As the series progresses, our monster meets up with a succession of antagonists from backgrounds at least as schizogenic as his own—no small feat, considering that Jason's own family dynamic makes Norman Bates look like the Beaver. Fatherlessness is their invariant theme. Little Tommy Jarvis must take on the adult responsibility of protecting his mother and sister by killing Jason in Part IV (*The Final Chapter*). Tina, the Carrie knock-

off who matches her psychic powers against Jason's uncanny brute strength in Part VII, kills her own father at the beginning of the movie (though it's *kind* of an accident, to do her justice). Even the copycat killer in the ignominious Part V, otherwise a narrative left-turn for the series, is revealed to be unhinged by the death of his son. The message sent in all these installments is hardly the conventional admonition to conform found in the teenage-wolf, blob, and zombie pictures of an earlier era: As befits the contemporary culture of the non-traditional family, in the *Friday the 13th* films teens from "normal" homes perish in gut-wrenching terror, and only the weak survive—right through the necessary (if regrettable) massacre not only of strong and beautiful age-mates, but often of their own entire bloodline. The anti-heroes of the *Friday the 13th* series have the spunk to face down Jason, but neither the power nor the will to rescue any of his many victims among their own friends and families. Like the cheering audience, they practically collude in the slaughter, only a little more ambivalently.

Like all monsters, Jason succeeds as a cult image through mechanisms not so much of fear as of identification. His physical

grotesqueness—before ever he raises a hatchet, grappling hook, or
(in a pinch) shovel—externalizes the adolescent's preoccupation
with appearance: both the fear that one will never inspire love and
the hope that one will inevitably inspire fear. In the awful jargon
of popular psychology, Jason is "special." Of all the parasitisms—
upon *Psycho*, *The Texas Chainsaw Massacre*, and *Carrie*, among
others—that animate and reanimate Jason, the most telling appears
in Part II: Before we ever see his "real" face, the lunkish, overgrown,
pre-verbal wild boy is masked by a hood identical to that worn
by John Merrick in David Lynch's fantasy of parental rejection and
reconciliation, *The Elephant Man*. Any teenager who does not
identify with a creature this hideously deformed is just not having
a normal adolescence.

But the true artistry of the *Friday the 13th* films resides in
their creation of an origin myth for one of the most persistent and
notorious metonymic devices in movieland, if not in recent popular
culture as a whole: Jason's hockey mask, a vacant-eyed, implacable
artificial visage that becomes far more frightening than mere defor-
mity. From the instant he picks it up in Part III—a magical moment
to rank with Scarlett O'Hara's vow never to go hungry again—
there can be no question what kind of fabulous creature Jason has
become; like a kachina dancer, he loses himself and becomes a
vehicle for his mission. Abstracting the essentials of physiognomy
in much the same way Kabuki make-up does, the mask reduces
personality to a single awesome dimension, suggesting that if Jason,
the abandoned, feral child, is something less than human, he is
also something more. Through its association with sport, the mask
also transforms the monster into an angry god playing a game with
human life: His victims become not only prey, but pawns. This is
indeed how the horror genre is classically supposed to work, turn-
ing the audience's own aggressive impulses toward symbolic satis-
factions, within conventions we recognize and accept. That is why,
when a teenage counselor is beheaded in one of these films, we
respond not as though a child has been murdered, but as though
an ace has been trumped. Furthermore, the sense that the action of
the film is really a game allows us to accept Jason's preposterous

resurrections: We acknowledge that at the end of each movie he may be checked, but not mated.

This response should serve as a healthy reminder of what ought to be obvious but appears, in popular discussions of the representation of violence in television and film, to be anything but: However low the art form, whatever you think of the subject matter, art is processed by audiences *as* art and not as reality—whether they are fully aware of it or not. New examples and genres quickly develop their own conventions, which are incomprehensible and often frightening to the unschooled. It may even be, ultimately, the fetishization of Jason's mask, rather than the exploitation of violent imagery, that is responsible for the character's success as a cult figure (as opposed to the simpler matter of the box-office success of the series). It provides, in fact, an object lesson in semiotics, and in the productive power of even the humblest of signs. First, in Part III, the crazed killer dons the discarded hockey mask of a prankster. In its primary function, the mask is *instrumental* as a device for protection. Though it already acquires a mystique through its substitution of a hard, fixed sketch of a face for pliable human features, in this new context it is a *signifier*, disguising Jason (with an irony perhaps crueler to the monster than to his victims) as a harmless, everyday figure—one of the boys. (Umberto Eco has said that a sign is anything that can be used to tell a lie.) In Part IV, the mask becomes an *icon*, metonymically signifying first Jason, then the more abstract conception of Death the Avenger he has come to represent; this is proved in Part V, where we find that the copycat killer can impersonate Jason, not only to his victims but to the film's audience, simply by wearing the mask. Already the mask has been elevated to a very exalted status, evoking a nihilistic, impersonal threat to being that transcends the circumstances of the sudden, senseless homicides portrayed. Finally, the mask is fully *fetishized*, acquiring powers independent of any human agency: At the end of Part V, the mask communicates directly with poor Tommy Jarvis, ordering him to kill; and in Part VI, the mask becomes a magic talisman capable of reviving Jason's decomposing corpse. In their own blasphemous way, the films uncannily mimic the process where-

by a cross of wood was elaborated, historically, from an instrument of torture to a sign of religious community and faith, and later to a powerful protection against sin, accident, vampires, and alternative lifestyles. The mask *is* Jason's real face, after all, and what's better, it can be purchased for maybe $2.98 by any kid eager to throw a serious fright into his peers or elders.

It remains to be seen whether this icon, established by a series of popular but not exactly beloved films, will endure long after their passing. Paramount Pictures did so badly with the misconceived *Friday the 13th, Part VIII: Jason Takes Manhattan* that Jason's earthly masters finally sent him to Hell in Part IX. (They should have known better: Removed from the woods and plunked down in the center of New York City, Jason becomes just another filthily dressed maniac armed with a machete.) Once again, the ugly duckling of movie monsters—though still more sinning than sinned against—sinks beneath the surface of Crystal Lake. There remains, floating on the surface of the culture, a blank, plastic mask—as frightening an image of the human countenance as recent popular art has conceived, excepting perhaps its eerily perfect counterpart: the insipid, ubiquitous Happy Face of the 1970s.

The Final Frontier

⌊JANUARY 1992 MAYBE I HAVEN'T EXACTLY GOT A HANDLE on this whole infinity thing, but if there are an infinite number of parallel universes (and who's to say there aren't), then somewhere, in a world very much like our own, there should be millions of creatures very much like ourselves, sitting in front of electronic devices very much like our television sets, watching reruns of sitcoms very much like *F-Troop*, *Three's Company*, and *The Patty Duke Show*—as well as soap operas and tabloid TV and two-minute news reports featuring bland correspondents who bring them word of war, epidemics, and ecological disaster; not to speak of miniseries, docudramas, infomercials, Home Shopping Network, and The Weather Channel. The only difference between us and them is that they've never heard of *Star Trek*.

In a way, one can't help envying them. They've been spared the hoo-ha of the sci-fi series' twenty-fifth anniversary, a strange compound of public-relations campaign and religious frenzy still in progress on our own primitive planet, celebrating the official recognition of a minor TV series from the 1960s as one of our major secular cults. The late founder of the *Star Trek* empire, Gene Roddenberry, may have had as wide an influence on American popular culture as anyone in our time. Aside from the original three years' worth of programs and *Star Trek: The Next Generation*—which between them seem to keep most of the country's independent television stations afloat—there have been six films, an animated cartoon series, and dozens of novels, comic books, inside histories, instruction manuals, and extraterrestrial phrasebooks. *Star Trek* may, in

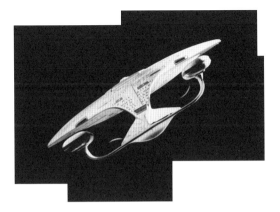

fact, be the whole reason liberal humanism has failed to make a serious response to the general trend toward Christian fundamentalism and patriotic frenzy in this country; apparently, all the forces within the American public that oppose imperialism and support diversity fled the Reagan era into an imagined future—attending hundreds of *Star Trek* conventions, inventing and circulating unauthorized adventures with alternative plot lines (including ones in which Captain Kirk and Mr. Spock are lovers and the Enterprise is finally commanded by a woman), and buying up, according to *TV Guide*, a half-billion dollars' worth of *Star Trek* merchandise. It cannot, after all, be political conservatives who have become so absorbed in the promotion of a mythology founded on one-world-ism, intergalactic multiculturalism, and the familiar panacea of progress. And if the liberals aren't all watching *Star Trek*, then *where are they?*

Even in its originating form, a major part of the appeal of *Star Trek*—along with the naïve wonders of tricorder, phaser, and transporter beam, and the garish colors that signified a wondrous future to a generation reared to read black and white as reality—was its vision of a world unconscious of race and innocent of class, in which a woman could be as darn good a yeoman as any guy on the ship. The series presaged the precise tokenism of later TV shows: the law firms with one white-female and one black-male partner, the emergency rooms with one Filipino orderly and one

gay-male nurse. By now, Nichelle Nichols' interview with Martin Luther King, during which the civil-rights leader asked her to continue in the role of Lieutenant Uhura as an inspiration to minority children, is part of *Star Trek* legend. The presence of the Vulcan Spock—a literary descendant of Sherlock Holmes but played as a kind of Confucian sage—signaled the inevitability, in the *Star Trek* mythos, of the eventual coöperation of widely differing cultures, even if it took a few centuries to achieve. In fact, the pairing of Kirk and Spock reads as a continuation of the line of male couples— one partner Anglo-Saxon and the other "exotic"—who tame the American frontier in Leslie Fiedler's famous analysis, *Love and Death in the American Novel*: Huck and Jim, Ishmael and Queequeg, and so on. Clearly, the man of color is still the sidekick, his complexion in this case due to the faint, exotic tinge of green blood. *Star Trek: The Next Generation* has, however, wisely played down this connection to a heritage of conquest. In the twenty-fourth century, the United Federation of Planets is careful not to interfere with aboriginal cultures; aliens of all kinds take part in decision-making, and only the Ferengi are vile.

In the interim between the old and new *Star Trek* series, changes have come in selected plot areas, and to some extent in the understanding of characters—and very decidedly in the role of special effects. What hasn't changed is the human scale. Several times its original size, the twenty-fourth-century Starship Enterprise remains primarily a vehicle for fantasy about the relations among humans on our own backward planet: our familiar, dystopian present, transposed to an undetermined future in glamorously distant galaxies. Only very occasionally is *TNG* (as we cognoscenti call it) able to convey any sense of the truly sublime—or for that matter, of the ridiculous, in particular the spectacular irony that we are able to sit in small rooms and view on small boxes what purports to be a representation of nothing less than the cosmos, in all its incomprehensible totality. This is why *Star Trek*, in any of its editions, seems most satisfying not when it shows us impressive aliens, gadgetry, or even those skin-tight uniforms, but when one of the crew turns and looks out the picture window to contemplate the vastness of space.

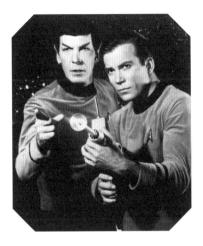

As a genre, what is called science fiction has always been rooted in awe: not, at its very best, pledged to the human scale, but to the non-, extra-, and even inhuman. Perhaps this dimension is generally missing from *Star Trek* simply because what was once a cosmos is now merely *space*, and empty space is not exactly telegenic. But it would be truer than all the extraterrestrial flummery. Whether there is Life Out There is not really a matter of probability theory, given an infinite number of stars, galaxies, or universes, but of human beliefs about life and death, being and non-being. There *ought* to be something out there, it seems, because that space is what we are travelling through right now, right here. The Enterprise *is* human enterprise, surrounded on all sides by a vast, cold emptiness that is not impressed. That is what *Star Trek*, much less anything else that shows on TV, cannot portray, not because it is unportrayable—*King Lear* does a pretty good job—but because the world of television occupies the space between the inside of an individual and the outside of the social world. Beyond that realm— a big enough world, to be sure, but a pretty limited one if we compare it to all of being, within ourselves, and beyond the human sphere—television cannot reach, because it may not step outside the magic circle of the system of consumption, the condition of its existence. The space the little ship moves through is death—and

not just some abstract conception of death, but everyone's personal, individual death: the one future we all hold in common with utter certainty.

In another universe, on another planet, someone is watching a different version of *Star Trek*, one deeply influenced by that world's version of Samuel Beckett, perhaps: a kind of science fiction that takes the unimaginable *longueurs* of space travel as inherently more interesting than rushing around everywhere at Warp Nine, just because they are truer to the nature of things. On another planet, outer space threatens to break through into human space as the world's ozone layer deteriorates, and hundreds of thousands of beings just like us are killed by a tiny virus no humanoid eye can see. On another planet's version of *Star Trek*, someone picks up a copy of Pascal's *Pensées* and reads, "The eternal silence of these infinite spaces fills me with dread." But no satellite dish has yet been invented that will bring in that transmission, and we will not be seeing that program on our own earthly TV.

Now *Voyager*

MAY 1995 HOWEVER FRIENDLY THE INTENTIONS of the United Federation of Planets, *Star Trek* itself clearly has imperialist ambitions. Other television series may have spin-offs, but *Star Trek* founds colonies, new footholds of its ethos popping up all across the primetime grid. No other television series has created a whole alternate reality to which viewers can escape, leaving the world we know behind—not even *The Brady Bunch*. But it is not, as might be imagined, the extraterrestrial exoticism—the occasional green-skinned alien or twenty-fourth-century hardware—that is responsible for the unprecedented transformation of production company into fanatical sect. Today, *Star Trek* is popular not because it goes where no one has gone before, but because it returns to the same familiar territory again and again. Wherever you travel on the various *Star Trek* series, you can be sure you've been there before. Captain Kathryn Janeway may be exploring a new quadrant of the galaxy on *Star Trek: Voyager*, but she is covering the same ground as Jean-Luc Picard and James Tiberius Kirk before her. At a time when daily life, and art that draws upon daily life, appear appallingly unfamiliar to the vast television audience, what is taking place on the Starship Voyager, centuries from now and light years away, has a certain comforting air—an aroma, perhaps, more of microwave popcorn than of Tyronian elk stew, or whatever *goyishe chazzerei* Neelix is cooking up in the galley. In other words, when the present seems obscure and alien, we are bound to feel nostalgia for the future—especially if it's a future that popular culture has been living with for twenty-five years.

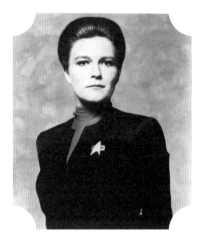

When it debuted, *Star Trek: Deep Space Nine* disconcerted fans by steering into the darker, funkier sci-fi universe of movies like *Blade Runner* and *Alien*. Ironically, in attempting innovation, the series has only managed to point up the clichés of the genre. Perhaps this is because *DS9* intentionally portrays the stasis and anomie of a post cold-war situation. Unlike the brave new world of *Star Trek: The Next Generation*, *DS9* seems entrapped in a view of history now in vogue among neoconservatives, one which expresses the dark side of America's national self-confidence—not to mention our insular arrogance: We must be about as far as social evolution can go, so this must be about as good as life can get. This is a complacency that breeds despair: If things aren't going to change much in the next few millennia, the future ceases to be of interest. But of course the future *has* to be interesting, because it isn't really the nation's or the species' or the planet's future that sci-fi fantasy depicts, but—metaphorically—the individual viewer's. And one's own fate cannot fail to be a compelling topic. These visions of utopia are fundamentally different from the classic one posited by Thomas More, who set his essentially political fantasy in another place, not another time. Paradise is possible on earth, but what the different *Star Trek* series portray is heaven: a promise of a world (or worlds) to come, after we have left this sublunary

sphere behind. By their basic premise, the shows offer a taste of immortality. As we watch, we survive long after personal death to see what mischief the Klingons and Romulans get up to. It is good to live forever. As the Democrats learned in the 1994 Congressional elections, it is not so much the party that offers change, but the party that offers the idea of a future—regardless of the particular future that it offers—that wins the electorate's massive, throbbing, fickle heart. This holds true even when the future offered is just an imaginary version of a specious past.

In *Voyager*, the mythos has found a new metaphor, one that inverts the original mission of the Starship Enterprise. Our travellers remain explorers by temperament, but they are no longer explorers by choice. They have been thrown into the farthest reaches of space by accident—well, the pretext is the interference of an advanced alien race, but the point is the same. This makes *Voyager* the first truly existentialist *Star Trek* series (see Heidegger on the sense of being "thrown" into the world). Indeed, by venturing out into the Beyond *beyond* the Beyond, the new series has become the first meta-*Star Trek*. Stranded as they are in the Delta Quadrant, it is even more than usually vital that the Voyager's crew should observe not only the Federation's but the *Star Trek* rulebook—that they should recycle plot points, moral lessons, and character elements from previous series. Thus they carry their home, and ours, away with them to distant stars.

Unlike the characters on DS9, who seem genuinely new and well-rounded but simply have not generated much viewer interest, the characters on *Voyager* recycle elements from previous series in elementary ways. *Voyager*'s Ensign Harry Kim is TNG's Wesley Crusher a few years on, the neophyte through whose eyes the core audience of adolescent males views the show's action; and Tom Paris, token white male, fills the anti-gravity boots of both Captain Kirk and TNG's Will Riker as an idealized bad-boy buddy for those teenagers to idolize, the kind of cool guy who wears Old Spice and quotes James Bond. There are certainly interesting new developments in these old themes, however. For example, the homoerotic undertones of compulsive womanizing were never

explored in the characters of Kirk or Riker as they seem to be in Tom Paris's desperate need to impress Harry Kim. (So far, however, the romance between the two seems to conform to the United Federation of Planets' "Don't Ask, Don't Tell" policy.) *Voyager*'s holographic Doctor obviously raises the same issues as did the android Data on *TNG*—issues that are presented as metaphysical, but are more properly psychological. They are, after all, about identity rather than about the nature of reality—about what it means to grow up as much as about what it means to be human. But the Doctor also introduces a neat new twist: As a mere computer program, he is turned off, shut down, as soon as he has completed his workday, making him the perfect symbolic representative of the 1990s white-collar worker—the demographic constituency that grew to adulthood within the now extensive domain of the *Star Trek* hegemony.

But more obviously, it is with *Voyager* that *Star Trek*, Inc. finally enters the multiculture—though the original Enterprise, with its image of all the races of the earth working together as one crew, may be responsible for the whole notion in the first place. (If you doubt the huge if subliminal influence of *Star Trek* upon the culture, consider the outcome of the 1992 elections. When the children of the sixties voted for Clinton and Gore, they were *seeing* Kirk and Spock.) Commander Chakotay is the male version of *TNG*'s Counselor Troi, sensitive as hell, as befits his Native American origins; while B'Elanna Torres is the female Worf, and Tuvok the black Spock. These simple inversions of the simplest of stereotypes just reveal the stereotypes' tenacity; we are to have our interest piqued by the exotic spectacle of a black intellectual, a female engineer, a male who consults his feelings. This is something the mythographers at *Star Trek* have always understood. Some of the most fascinating and satisfying fictional characters work *because* they exploit stereotypes—or the stereotypes' relation to archetypes, which doesn't always get enough credit. The question is whether you exploit them in the most mindless and offensive way (as does the vast majority of putatively realist television and film), or whether you use them, just like any other element of story-telling, with intelli-

gence and nuance to concoct something rich, strange, and human, as *Voyager* succeeds in doing.

Among all the changes that remain the same, *Voyager*'s "concept," as they say in Hollywood, comes down to one outstanding breach of custom: the woman at the helm of the ship. Why is this even an issue? Because the show's fortunes depend upon the willingness of males aged 15-47 to accept the idea of a woman commanding a spaceship—and more significantly, a space*show*. As it really will influence the next generation (to coin a phrase) to see a female hero in charge in outer space, the risk that *Voyager*'s producers have taken is a laudable one; and it's already paying off, revitalizing the *Star Trek* mystique and resulting in damn good television. But I think the makers of the show, who certainly know their myths and fables, realize that the female leader is hardly an innovation in the tradition to which all the *Star Trek* shows belong, especially considering *Voyager*'s unique mission. Beneath all the phasers, transporter beams, and dilithium-powered Warp drives, every *Star Trek* show so far has essentially been about running away from home. And if it is Peter Pan who captains the Lost Boys in Never-Neverland and fights the pirates, it is Wendy who leads the children back to the security of their home.

So we can easily tell where this particular incarnation of *Star Trek* is headed, with its themes of abandonment and loss. After many close calls with temporal disturbances and wormholes, encounters with alien races and internal dissension, Captain Janeway will one day discover that she has only to click her heels three times and repeat "There's no place like home" to return to our cozy little corner of the galaxy. The parallel to Dorothy Gale's marvelous adventure is in places too exact to be entirely coincidental. After all, the captain and her crew are snatched up from familiar surroundings by the galactic equivalent of a tornado; while Neelix, the first really beastly alien to be featured on a *Star Trek* series, is clearly a Cowardly Lion; and the holographic Doctor, like Data, is a Tin Man in search of a heart. What is really of interest, though, is that Captain Janeway inspires the viewer not only because she is something new, but because she is something very ancient, of Dorothy and Wendy's

line. The male hero may go far afield to find the patriarchal god—to challenge him, or replace him, or make atonement to him. Jim Kirk and Jean-Luc Picard knew him as a sky god, to be found only where no one has gone before. But the female hero brings her brood home.

Is Captain Janeway's spectacular success with audiences a sign of progress or reaction? As so many *Star Trek* plots have labored to illustrate, the difference between the future and the past is sometimes a mere convention, a bubble in the temporal flux. Directly following the Republican victory in both houses of Congress, the *Star Trek* brain trust has once again proved its uncanny facility for giving voice to America's hopes, fears, and fantasies by offering a series about an old-fashioned, new-fangled, sexual-stereotype-confirming-and-defying, multicultural family-by-affinity turning away from the farthest reaches of space and seeking the way back home. For it appears that it is in the journey homewards, not in the voyage out into dark, cold space, that the future, for the present moment, lies.

The Age of Seuss

⌊JANUARY 1993⌋ DID YOU EVER HAVE THE FEELING there's a WASKET in your BASKET? . . . Or a NUREAU in your BUREAU? . . . Or a WOSET in your CLOSET?

You are not alone. A deep suspicion that the poverty of everyday life may suddenly be overwhelmed by an eruption of the uncontrollably marvelous, revealing the absurdity that lurks beneath the surface of the most ordinary objects, is the hallmark of the Seussian sensibility. Dr. Seuss was the Homer, the Milton, the Mother Goose of our 'boomer youth. The universal influence of *Green Eggs and Ham*, *Go, Dog, Go*, and *The Cat in the Hat* may be gauged by the fact that hardly a city in the United States is without a rock band named after a Beginner Book.

Author, illustrator, and industry, Dr. Seuss—or Geisel, Theodor Seuss (1904-1991), as he is known to librarians—began, like the great artist-writer William Blake before him, with the enlightened assumption that children's books could really constitute art and literature intended for children, not merely manuals of indoctrination in behavior convenient to adults. The run-of-the-mill pre-Seussian children's book was a moral tale or exemplary lesson, in which good children were rewarded and bad ones punished—a

model carried on these days, in a more liberal style, by those books intended to help children adjust to the traumas of divorce, death, and parents' alternative lifestyles. If they teach something relevant about life, they are still culpably deficient in the satisfaction and cultivation of children's feelings. However difficult it may be to formulate the distinction theoretically, what child does not recognize instantly the difference between art and propaganda?

And it is as art, not merely as educational material, that Dr. Seuss's work should be appreciated. The radically individualist naughtiness that appears in so many of his books is more than a strategy he uses to win the young reader's attention; it is a core value he cherishes. Fantasy constitutes not only the style, but the central subject matter of Seuss's work. The typical hero of a Seussian meditation on the power of fantasy either imagines or discovers an alternate reality, a world's worth of personal meanings proliferating outside the customary field of attention. Horton hears the Whos in Whoville; Marco spins from his own fancy the vast, bizarre procession that crowds onto Mulberry Street; the narrators of *If I Ran the Zoo* and *On Beyond Zebra* conjure up whole menageries of esoteric beasts, savage or sociable. Seussian fantasy goes far beyond the vulgar romantic cliché that exercising imagination is "good" for children in some undefined way; Dr. Seuss's heroes grow morally as well as intellectually through acts of imagination, often in vividly, literally realized ways. The child in *I Wish That I Had Duck Feet*, for example, uses his imagination to change himself practically and radically, in a manner very different from—perhaps even antithetical to—mere wishful thinking.

The improvised visions of Seussian visionaries are styled not only as worthwhile accomplishments, but as unique and private ones: They do not have to be shared, particularly with inquisitive parents, like the father in *And to Think That I Saw It on Mulberry Street*, or the mother in *The Cat in the Hat*. Most psychologists and educators now see this encouragement of an autonomous self, strengthened by idiosyncratic fantasy, as central to Dr. Seuss's appeal and value: A few have argued with typical and ludicrous

earnestness that his books encourage children to dissemble with their parents, to develop a zone of solitary imagining inaccessible to parental inquisition. No doubt there is a parents' coalition somewhere dedicated to showing that the Cat in the Hat books—"I Can Read It All by Myself" being their slogan—are tools of Satan, suggesting as they do that some small corner of children's lives might be naturally and legitimately outside adults' direct control.

Dr. Seuss's many child-heroes—and the animals that stand in for children, such as Horton and Thidwick and Yertle—derive their distinctive pathos and force of character from their author's understanding of children's powerlessness in a world arbitrarily and unfairly run by boring, venal adults. In *If I Ran the Circus*, little Morris McGurk envisions the Circus McGurkus, the World's Greatest Show, in the vacant lot behind old Sneelock's Store. As the fantasy unfolds, however, the main attraction turns out to be, time and again, Sneelock himself, the dull, almost somnambulant figure Morris has supplanted in fantasy. In the illustrations, Sneelock complacently puffs his pipe as he is subjected to various entertaining tortures—menaced by wild animals, shot from a cannon, or dumped into a goldfish bowl—all the while wearing the same vapid, beatific expression as Horton the elephant (in *Horton Hears a Who*), sitting on his egg: part glibness, part Buddha under the Bo tree. This scenario allows Morris to mock the powerlessness of adult reality in the face of omnipotent childish fantasy, ridiculing Sneelock as the most unlikely of daredevils—and yet it is unified only by an underlying dependency on the adult as a heroic, indestructible figure. (The book was dedicated by Dr. Seuss to his father.) Children develop imagination because they have no choice. They cannot survive in the world if they actually kill their parents.

Really good fantasy depends on ambivalence for its depth and character, in children's literature no less than that intended for adults. But Seuss's fantasies go farther still. As instanced in *Duck Feet*, children are likely to dream of "being big" in the most literal ways. It should come as no surprise that the fantasies of Dr. Seuss's small protagonists, like those of real children (as well as real adults), reveal their sources in the body, in the infantile style of erotics that

is somewhat prejudicially called polymorphous perversity. The images of the child in *I Wish That I Had Duck Feet* trying out life with a whale's spout, a long tail, and an elephant's trunk are all as close to an explicit treatment of phallic fantasy as we can expect to find in a book intended for children, not child psychologists. The Seussian theme of the secrecy of fantasy appeals to children's developing sense of mastery of their own bodies, and ultimately to their fantasied images of their own bodies, especially the parts they are taught should be treated as private. Thus, while through most of *If I Ran the Circus*, Morris's fantasy concentrates on the adult figure of Sneelock, he takes center stage himself with the Organ-McOrgan-McGurkus: "With its hot steaming pipes of gold brass-plated tin / Snorting all sorts of snorts in a bummbeling din." This massive organ is no more subtle an image than "the wily Walloo / Who can throw his long tail as a kind of lassoo," imperilling Snee-lock, because the Walloo "can capture whoever is standing behind." Seuss's drawing shows the tail to be only the most perfunctory fantasy disguise for excrement. What the child is really threatening the adult with, in a playful way, is the production of feces, in suffi-cient quantity to overwhelm the adult world.

Seuss's illustrations often reinforce the very naughtiest of his themes, including this underlying identification of imaginative pro-duction with defecation. A telling instance is the little parable of *Gertrude McFuzz*, a bird ashamed of her paltry plumage, who eats some magical berries (referred to as "pills"—like laxatives?), and begins sprouting beautiful tailfeathers that "sparkled like diamonds and gumdrops and gold! / Like silk! Like spaghetti! Like satin! Like lace! / They burst out like rockets all over the place!" The anom-alous spaghetti suggests Seuss's anal theory of creativity, if the illus-tration alone were not enough. Curiously similar in theme is the cover drawing for the explicitly naughty-sounding *There's a Wocket in My Pocket*; or the strangely, unnecessarily excremental little worm that emerges to win the day in *The Big Brag*.

This notion of producing vast amounts of highly prized excrement/fantasy is arguably the very core of Seussianism. What might be called the theme of proliferation is the most characteristic

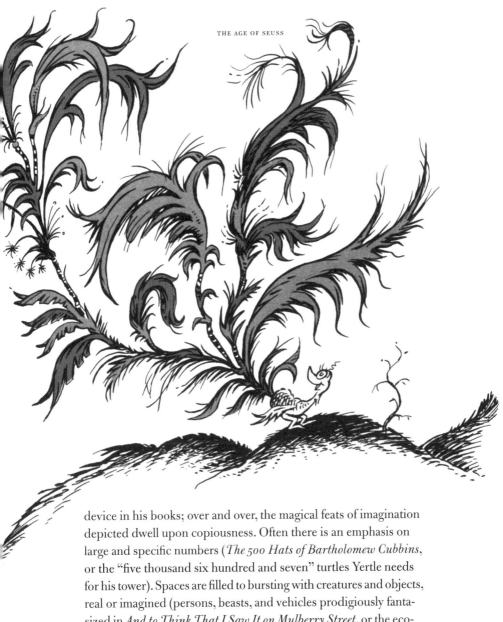

device in his books; over and over, the magical feats of imagination depicted dwell upon copiousness. Often there is an emphasis on large and specific numbers (*The 500 Hats of Bartholomew Cubbins*, or the "five thousand six hundred and seven" turtles Yertle needs for his tower). Spaces are filled to bursting with creatures and objects, real or imagined (persons, beasts, and vehicles prodigiously fantasized in *And to Think That I Saw It on Mulberry Street*, or the ecosystem's worth of animals that come to live in the horns of *Thidwick, the Big-Hearted Moose*). Again the illustrations amplify the explosive character of the fantasy: Whatever happens to proliferate in the particular story creates a glorious mess, composed of splatters, splotches, and drips. For the adult reader, Dr. Seuss's pictures are a reminder that the artist facing a blank page recaptures the latent

power of a child about to smear feces on a clean wall.

Then, as suddenly as these proliferations of circus acts, wild animals, or household objects come into existence, they disappear or are whisked away: It is equally a part of the Seussian world that messes are cleaned up, the focal point of much suspense in *The Cat in the Hat* and *The Cat in the Hat Comes Back*. The latter, however, shows the difficulties of cleaning messes: A weirdly atmospheric and profound book, even for Dr. Seuss, it almost manifestly presents an allegory of the Return of the Repressed. It cannot be accidental that the big pink spot that begins as the Cat's bathtub ring and is shuttled all over the house, smeared from one place to another, finally comes to rest as a stain square in the middle of the parents' bed. Eventually the stain is attacked by the little cats A, B, C, and so on, who live inside the Cat's hat, but none of them is able to clean up the mess, until little cat Z appears with the VOOM! that cleans all the snow the other little cats have turned pink—and here we have to throw up our hands and wonder whether there is not behind this particular image some crypto-Christian meditation upon the power of grace and forgiveness of sin.

More likely, however, it is an instance of Dr. Seuss's belief in the transformative power of the truly absurd—a quality in which he echoes his classical forebears, Edward Lear and Lewis Carroll. The messes engendered in Seussian fantasy are always cleared away through an accommodation between reality and fantasy— between adult repression and the unruly body of the child. In *The 500 Hats of Bartholomew Cubbins*, whenever the hero's hat is removed (voluntarily and later forcibly) as a sign of respect for the king, a new hat spontaneously appears, with its naughty, indomitable feather "that always pointed straight up in the air." Even when Bartholomew does his best to conform to convention, the feather returns. Stranger still, the more persistent the attempts to knock the hat off his head—until finally his life is in peril—the more splendid and assertive the hats become: The 500th hat is festooned with "ostrich plumes, and cockatoo plumes, and mockingbird plumes, and paradise plumes" and bears "a ruby

larger than any the King himself had ever owned . . . Beside *such* a
hat even the King's Crown seemed like nothing." The ego-driven
king cannot tolerate the child's persistent id, but when Bartholo-
mew's defiance of repression is presented as art, he is avid to pur-
chase it.

Some readers may take *Bartholomew Cubbins* as an allegory
on the inevitably libidinal and subversive character of art; for oth-
ers, the story does not go nearly far enough in subverting adult val-
ues. After all, Bartholomew takes the king's money and goes home
happily hatless. But I think his attitude is distinctly postmodern:
Selling out is his way of remaking the world according to his own
vision, which is mainly a vision of how ridiculous adults are. Post-
modernism might, in fact, be understood as the Seussian sensibility.
Like Seuss's child-heroes, it mocks the earnestness of the adult
world: Contemporary artists play roles and photograph themselves
in costume because they see adult life as a matter of playing dress-
up. Like Morris McGurk, they relish the naughtiness of the poly-
morphously perverse; indeed, perhaps the most appropriate title
for Robert Mapplethorpe's notorious " X Portfolio" might have been
And to Think That I Saw It on Mulberry Street. Above all, postmod-
ernism insists that the spirit of art is the spirit of play. Its architects
self-consciously seek out the bright colors and elementary forms of
children's art, styling skyscrapers as toys, houses as playpens.
Squinting hard at those buildings, we can discern the giddy, improb-
able towers of Dr. Seuss's cloud-capped cities. Others may have
been celebrated in more monographs and museum retrospectives,
but Dr. Seuss was that rare style of artist that defines an age.

A Season in Sesame Street

ᴍᴀʀᴄʜ 1995 [READERS OF POETRY] KNOW THAT Rimbaud invented
the colors of the vowels and produced rather cleverly cryptic
images associated with them; that, as his farewell to literature, fol-
lowing his abysmal homosexual adventure with his fellow-poet
Verlaine, he wrote [*A Season in Hell*] . . . in which he described the
brutalities and the mental aberrations connected with the passage
through inferno that occurs when life ceases to be the festive dream
of childhood, when the magic fades away, when love becomes a
deception and the God we have been waiting for fails to appear.

—ANNA BALAKIAN, *The Symbolist Movement*

A black, E white, I red, U green, O blue: vowels,
Someday I'll tell your hidden origins:
A, black girdle fuzzy with shiny flies
Buzzing around the cruel, stinking rot...

—RIMBAUD, *Voyelles*

No single figure has been as important as Rimbaud in estab-
lishing childhood as a major theme in modern art and literature.
His preoccupation with the body and his evident intention to shock
figures of authority, which have since become traditions of the
avant-garde, are often ascribed to his staggering precociousness:
He wrote his first great poems at the age of fifteen.

The following recently discovered poem, here translated and
published for the first time, is definitively dated to 1860, when the
poet was only five years old. It therefore casts new light upon some

of Rimbaud's most significant and influential themes: his passion-
ate nostalgia for infancy (even as he depicts it as a period of tor-
ment, isolation and confusion); his bizarre and disjunctive imagery;
and his assignment of transcendent, mystical meanings to the let-
ters and sounds of language. The poem is replete with obscurities
that will doubtless keep scholars busy for years to come.

A Season in Sesame Street

A to Z, absolute, anamnestic, as always:
Only authority I acknowledge, source of all wonders.
Ah! To be cast away, adrift in the pure
and profound arbitrariness of the symbolic!
All that these things have in common
is that they begin with the same letter,
or that they are being counted,
or that they are the same shape.
A fox in a tux plays the sax,
an ant carrying an apple. Amazing.

But what is this barbarous land? Where bats breed
with baboons, where bubbles in air betoken
bathtime tunes with Bert and Brad.
Believe in yourself! they sing.
Be different from everyone else,
but beyond all else, be normal! Behave!
Bastards!
Can you tell me how to get—
How to get out of this place?
The colors. Too many blinding colors,
colors of dancing stars and circles,
of soldiers' blood and schoolboys' vomit.
Cookie Monster? No! You are unjustly defamed.
It is the cookie itself that is monstrous!
Cover your nose when you sneeze! Please!

Double-dutch dancers
of each race and more than one sex—
daring ducks, dolphins, doggies,
dietary admonishments,
dreams, dimples.
Dwarfs. Death. Despair.

Everything that exists is to be found here:
elk, elephants, elbows.
Elmo. Ethnic diversity.
Eternal enmity sworn
between square lovers and triangle fans.
Fuzziness, favored form of cuteness,
(the false face ferocity puts on to fool us):
mother's furry, fevered parts.
Father's fly, fat fingers
feeling their way in . . . forbidden!
Fun.

Gee, Gordon, Grover!
Going to school is great!
Gorge rises.

Hopalong Hamster head honcho here:
harps, hula hoops, haystacks—
Horrible hallucinations of Planet H!
Home can be a castle or a little shack.
A home can be near water or a railroad track.
A home can be of brick and steel, or grass, you know.
A home can be an igloo made of ice and snow.
Home can be a dark hole to crawl off to,
licking the snot, blood, and tears from my lips,
holy vengeance planned against the oppressors!
Home, homily, homicide.
Happy ending.

Innocent, isolate,
I idyllic, idle
without parents or teachers—
only there is one
immanent, intimate always:
generous glowing tube of heavenly images, icons, ideals!

Jabbering of jams, jellies, justice,
jutting-bellied juveniles jest, jape.
Kangaroos keep kissing kittens—
then kicking them in the kidneys.
K! Who has condemned you to silence
in knighthood, in knowledge, in knives?!
Little letters, benign, beneficent.
Little letters, lightly laid in long lines.
Little letters like lice.

Mysteries of grammar, of traffic safety, of birth!
Music of bells, flutes, horns: Monster music!
Me, the one and only person I can stand.
Me lost me cookie…
Monster songs. Modernity begins with the monstrous,
the anomalous. (Make a face in the mirror!)
Where each individual is special, everyone is an exception—
every child is a monster, every mom a monster mom.
Numbers in profusion, nursery-school numbers—
none so numinous as Number One and Number Two!
Otherness! Oppositions! High-low, fast-slow,
short-long, weak-strong! Out! In! Oppositions!
Pickles, packages, people in paintings. Puppets.
People, it seems, come in all colors
but are the same beneath the skin.
(*But who probes beneath the skin to see?*)
People are puppet-sized—puppetized.

Queer, queasy, quavering, Queen Latifah
and Ruth Buzzi appear together
for the first and last time—
rapping!
Recycle! Remember!
Rubber ducky, rubber ducky—slimy, insistent, vague!
Rubber ducky, rubber ducky—You are not here to bathe!
Rubber ducky, rubber ducky. *What are you?*

Storytime. Shadows fall, sadness settles
like a spell on Mr. Hooper's store.
Silence of sign-language segments, seriousness of purpose.
Softness, sweetness.
(*Stiffness! Stickiness! Sphincters!*)
Twelve! Twenty-one! Thirteen! Two!
Thirteen testicular toughs tweaking a
tightening the tourniquet, twelve
terrible teamsters terrorizing a timorou
Twenty-two tapeworms! Thirty-three
Thousands of teeming ticks, torturing
Up, down, in, out, over, under.
Use your imagination!
Up underwear, umbrella. Unfair!

Vagrancy, vacancy of vignettes.
Vast, vital vanities void now,
vulgarized in these visions—
vice, violence, voiceless.
Words, words, words that start with . .
No! I will not speak the name!
When will mother return?

X, where journeys end, and treasure lies buried.
X, for those unlettered to sign their consent.
X, sacred sign of negation, crossing out all errors.
Yes. AlwaYs. Y not?

Zut!
Zero!
Zero of ends and beginnings, Omega of Alphic A!
Zombie chieftain of living dead letters, dead-alive meaning!
Zzzzzzz—naptime approaches, and the Big Bird
of sleep gathers me in his clumsy, flightless wings.
Ah, Bert! Eh, Ernie! O, Oscar!
Now I know my ABCs. Tell me what you think of me!

Out of Aladdin's Lamp

JANUARY 1994 THE MOST RECENT ANIMATED FEATURES from the Disney studios reveal Tinker Bell waving her wand over some previously unexplored corners of cartoonland. The female heroes of *The Little Mermaid* and *Beauty and the Beast* are given at least the opportunity to act heroically before they resign themselves to an eternity of bliss with those same damn princes of long ago; and *Aladdin*, however parochial the film's assumptions, is certainly an improvement, ethnic-diversity-wise, over *Song of the South*. Maybe it really is a wonderful world of color after all.

The real news, however, is not that Disney has taken the plunge into the new culture of multiculturalism, but that it has rediscovered and revised its own traditions along the way. With all due respect to Lady, her Tramp, and the sublime Cruella DeVil, the classic Disney films of the past succeeded not as realist fictions inhabited by figures who just happened to be animated blobs of ink, but as fairy tales. Unlike naturalistic characters, fairy-tale protagonists do not merely *develop* in seeking to achieve their character goals, they are *transformed*, in some clearly and essentially symbolic way. Snow White is revived from death to life; Sleeping Beauty is awakened; Cinderella becomes a princess. Such qualitative transformations ensure that, unlike naturalistic characters, these magical beings magically live happily ever after—not because all their problems are solved, but because it is far better to be a princess than a peasant, better to be alive than dead.

Perhaps the most perfectly realized of these fairy-tale films is *Pinocchio*. The little wooden puppet is clearly the progenitor of

Disney's recent string of films: *The Little Mermaid, Beauty and the Beast*, and *Aladdin* all follow the fortunes of a central character whose aspiration is simply to become fully human, and whose goal is achieved by the end of the picture. Since this is equally the destined desire of all children, the popularity of the Disney films with a children's audience is not hard to understand; since it is also the secret hope of most adults (based on the secret fear that they have not quite attained true humanity yet), the universality of the Disney features is easily explained. Moreover, the transformations of fairy-tale plots contrive to reveal their protagonists' essential states, underneath the appearance effected by purely external and contingent circumstance. Pinocchio, for instance, is able to become a real boy outside because he has always been a real boy inside.

Consider *Pinocchio* as the sunshine counterpart to its dark contemporary, *Citizen Kane*. The Disney film shows that it is possible, if you are "brave, truthful, and unselfish" (as the Blue Fairy tells the not-yet-real boy), to become human even if you do not enter the world that way—while the disjunctive scenes from Kane's life question whether he can even be considered real. Pinocchio, fashioned by another, finally writes his own ending and becomes his own man; Kane, the quintessential self-made man, is ultimately no one at all. In the new Disney features, what the protagonist must learn would also be incomprehensible to Kane: to "be yourself," in the simplistic jargon of our own day. Becoming human means acting unselfishly, as Pinocchio ultimately does in rescuing Geppetto from Monstro the whale; as the Beast does in letting Belle go when he most needs her to redeem him; and as the Genie of *Aladdin* does in releasing the young hero from his promise to free him. Even if the approach to plot begins to seem formulaic, there is wisdom as well as appeal in portraying true humanity as dependent on altruism.

The real success of the Disney animated features, though, depends upon the particular symbolism used to signify becoming human. For an audience of children, full humanity means the fantasied independence of adulthood, pictured in the Disney fairy tales as mobility—actual physical freedom. Pinocchio, eventually,

literally has no strings; he is a plaything made free (while Charles Foster Kane, prisoner of Xanadu, remains enslaved by the memory of a childhood toy). Ariel, the little mermaid, gains her legs; and the beauty Belle's friend and admirer, the Beast, is liberated by love from his castle and his grotesque, hulking form. In *Aladdin*, the Genie is finally freed from the compulsion to serve the wishes of others and escapes the confinement of his lamp.

Beyond the realm of developmental psychology, however, these not fully human characters rise into an aesthetic dimension that borders on metafiction. Even if they are not explicitly aware of their status as cartoon characters, their plight as not-human beings depends on the audience's perception of their status as cartoons, as flickering images shot from no human original—pure creatures of imagination. The plots of the Disney fairy tales recapitulate the actual transformation undergone by their characters, from lines of ink and fields of color to persons with whom the audience can identify, and whose fates hold them in suspense.

It is only in *Aladdin*, however, that the metafiction seems to become self-conscious, as well as essential to the film's plot trajectory and complex of themes. Maybe the street-rat with the heart of a prince really is the protagonist of the story, but the Genie is still the central character of the film. As a fantastic creature seeking liberation from the conditions of fantasy, he is, practically, a fictional character obsessed with his own unreality. His self-consciousness as a cartoon is realized by his rapid re-transformations from guise to guise. The Genie is conceived as a visual realization of Robin Williams' powers of mimicry and hysterical speed of delivery. As the human actor's voice shifts, rapidly creating and casting off personae, so does the Genie's appearance: from William F. Buckley to Ed Sullivan, man to woman, child to adult. In a sense, Williams is the real auteur of the film, since the formal and thematic coherence of the film hangs on his performance.

In *Aladdin*, animation is not employed merely to save the expense of live actors and special effects, but to create a being who is animated in his essence—the Genie. Constantly in flux, continuously transformed from frame to frame, he embodies the nature of

the medium. If he is a descendant of Pinocchio, it is by way of *Duck Amuck*, the 1953 Warner Bros. cartoon in which Daffy Duck's usual trickster's persona is magnified by a consciousness of himself as cartoonist's pawn: Daffy is drafted, revised, and redrawn, plunged into elaborately horrific situations, and suddenly rescued—only to be plunged into worse danger, and abandoned in inappropriate settings according to the cartoonist's whims. The result is deeper and more disturbing than what we expect from a Warner's cartoon; this is something like tragedy. When we learn that the cartoonist in control is really Bugs Bunny, the pains he inflicts on Daffy seem nastier than we are accustomed to. In contrast to the playfulness of a human cartoonist, it seems Bugs is tormenting the *real* Daffy, since he exists within the cartoon victim's own two-dimensional world. In something like the same way, the Genie's desire for freedom, and his exhilaration upon achieving it, are conditioned by his existence as a creature of cartoons. The audience experiences the same emotions with both a directness and complexity that could be elicited by no human actor.

In the hundred years or so that motion-picture photography has been around, the cinema has not succeeded in liberating itself from the idea that it offers a true picture of the world, despite the efforts of formalist directors who have explored the medium's capabilities beyond the fundamentally mimetic. Now, along with cartoon characters who aspire to become real humans, there seems to have developed a trend to adapt human actors to the needs of cartoon characters. The cartoonishness of comedies and action movies has been deplored as evidence of the general dumbing-down of popular entertainment, or as yet another dire consequence of Hollywood's utter submission to marketing strategies. But it may just be a confrontation with an issue that has been around since the early days of cinema: In a two-dimensional, photographic medium, the image of the actor is no more real than the image of the cartoon. And it may be that, as with all art, the way the medium depicts people as acting characters—how it portrays our motivations and goals, and construes our nature as autonomous selves—depends more on the medium's own capabilities and limitations than on those of actual,

living humans.

What makes *Aladdin*, within its own time and context, a great film is its rare concerted unity of theme and form: the perfect use of the medium to reflect upon itself—not merely to be clever or fit a trend of the times, but to illustrate, by exploring the nature of the art form, the desperate stakes of personal freedom. The Genie's character-line is an irony piled on top of a paradox. The irony is that his condition of constant and unexpected change looks, from the viewer's standpoint, more like freedom than the freedom to which the Genie aspires—the ordinary reality of the everyday life that we more-than-cartoon beings know. The paradox is well expressed in a lesson Aladdin learns, and puts to good use, about the nature of genies: "Phenomenal cosmic power, itty-bitty living space." This astonishing disparity holds true also for the vast scenes that overwhelm the audience, as contrasted with the itty-bitty celluloid frames that produce them. Indeed, it holds generally for all the vast projects of the imagination and the itty-bitty symbols used to contain and communicate them.

The Dark Side of Disneyland
by Donald Britton

MAY 1989 CEL NO. 1: You're standing in front of the putative "popula-
tion sign" of the Old West mining town in Frontierland's Thunder
Mountain Railroad. On it, you see a series of crossed-out census
figures indicating that the town's inhabitants are being slowly but
inexorably wiped out. The alarming implication is that they've all
perished on the very runaway train you are about to board. You ask
yourself: Why is it necessary for a roller-coaster ride to go to the
trouble, even in this mild and indirect way, to create the impression
that the experience might kill you?

CEL NO. 2: You're standing in the mock graveyard that you
must pass through while on line for the Haunted Mansion. Here
are the crypts of Trudy Departed, M.T. Tomb, U.R. Gone, I.M.
Mortal, Ray N. Carnation, and others whose names punningly antic-
ipate the ghosts and ghouls you will encounter within. You also
find tombstones with creepily crude rhymed inscriptions like, "Here
Lies Brother Fred; Great Big Rock Fell On His Head" and "R.I.P.
Edgar R. Bender; He Rode To Glory On A Fender." As in the elab-
orate but decidedly unfrightening Haunted Mansion itself, you
can't help wondering: Why are they going to all this effort to make
human death appear as a corny, unreal joke?

CEL NO. 3: You're nearing the near-catastrophic final moment
of Star Tours. You've just been propelled on a dizzying intergalac-
tic joy ride. The spacecraft you've been riding in jerks to a sudden

halt—narrowly avoiding a crash with a moving truck marked "FUEL" that explodes into flames. You find yourself thinking: Isn't it just a little odd, at *Disneyland*, to find millions of dollars of engineering and special effects lavished on a state-of-the-art ride whose primary achievement is that it produces not simply an exceedingly realistic sensation of a journey through outer space, but the very palpable illusion that you are about to die—and violently and senselessly at that?

As these examples suggest, one doesn't have to look hard to see that there is a dark, even somewhat sinister side to Disneyland which is as much a part of the total experience as its well-scrubbed optimism and unrelenting good cheer. In counterpoint to its more obvious sweetness and light, throughout the park one finds evidence of a profoundly morbid preoccupation with death, violence, and human decay. Some might say that the presence of a few somber notes is a dramatic device to provide contrast, to accentuate and intensify the prevailing sunniness. But the fact is, Disneyland confronts us so frequently with images depicting death and its terrors that, though the images themselves are never really terrifying (except to small children), they are clearly crucial to what this particular Magic Kingdom is all about.

It is important to remember that Disneyland is no more an accurate anthology of the fairy tales and cultural myths it exploits as subject matter than it is your average thrill-a-minute amusement park. It is, rather, a highly manipulative, programmed environment with a distinct vision of its own to convey. We would come closer to the truth by saying that fairy tales (and other similarly structured narratives throughout the park) are the materials Disneyland uses to express what can be called its *cartoon sensibility*. This is a sensibility predicated first and foremost upon the infinite elasticity of pictorial space as embodied in cartoon animation. Indeed, the generative principle at work in Disneyland is not the fairy tale at all, but the cartoon—or more precisely, the attempt to translate into three dimensions the exhilarating ductility of time and space that can be approximated in cartoon illusionism. To understand the curiously demented messages Disneyland communicates on the subject of

death, you must look closely at the manifestations of this principle throughout the park. What you see is that representations of death at Disneyland express a fundamental contradiction in the park's doomed project: to bring two discrete realities—the biological, time-bound world of the human being and the artificial, timeless world of cartoons—so close that they actually *touch*.

But I'm getting ahead of myself. For now, it will be helpful to narrow our focus a bit. I'd like to concentrate on the questions raised by two of Disneyland's most puzzling but telling moments. The first question involves the symbolic content of a paradigmatic Disneyland ride, and the ways it explicitly enacts and defines Disneyland's central thematic concerns: *Why is the main character depicted in the Snow White ride not the pure and innocent Snow White, but the Wicked Queen who tries to kill her with a poisoned apple?*

The answer to this question will take us only to the border of understanding, not across. In the second part of this essay, we'll push farther, and probe the way Disneyland's themes fit into the implicit conceptual structure that informs Disneyland as a whole. We will ask: *Why is the reverential museum-style exhibition devoted to Walt Disney on Main Street USA paired with the rather freakish audioanimatronic resurrection of the most famous assassination victim in American history—Abraham Lincoln?*

What I hope will emerge is a deepened and more complex response to Disneyland, and especially an appreciation for what makes Disneyland uniquely Disneyland: the willful and poignantly perverse effort to make life into a cartoon.

I

The storybook rides of Fantasyland are the emotional core of Disneyland. Updated and technologically refined over the years, these rides were among the park's earliest attractions, directly inspired by the Disney animated films whose financial success made Disneyland possible in the first place.

While all the storybook rides are remarkably well-crafted spatial sequences—positively the *ne plus ultra* of what might be called kinetic, participatory sculpture—they vary significantly in

their individual approaches to narrative. Some, like Alice in Wonderland and Pinocchio's Daring Journey, are enchanting but awkward multimedia hybrids: three-dimensional illustrated tours of highlights from their cartoon originals, which in turn are fractured and distorted variants of their literary or fairy-tale sources, which in turn are variants themselves, etc. Other rides use characters and visual references from their movie versions only as pretexts for creating quasi-narrative environments and spectacles. They abandon linear plot altogether, fabricating instead a continuum of symbolic and highly-charged scenic tableaux formally more appropriate to a ride than to a story.

Snow White's Scary Adventures is the most successful of the pure "ride" rides. It orchestrates fragmentary elements from its cartoon source into an entirely unique new whole, with a logic and momentum of its own. The ride thrusts you directly *into* the fiction: You aren't told a story, you *are* the story, you *are* Snow White. But the reason Snow White's Scary Adventures is the quintessential Disneyland ride is that its core conflict is the primary energizing drama of Disneyland itself: the threat to youth and beauty by old age and death.

Significantly, the drama starts to unfold even before you have set foot in one of the little buggies that carry you to the cottage in the forest where Snow White lives with her Dwarfs. It begins in the little square near the main gate of Fantasyland, just outside Sleeping Beauty's Castle. Looking up at the second-floor window above and to the left of the ride's entrance, you are startled to see heavy curtains being drawn slowly, deliberately apart. Standing at the window, surveying unsuspecting tourists in the square below with an ominous gaze, is the beautiful Wicked Queen from Disney's animated version of the Snow White story. She pauses several seconds. Then, having apparently seen enough, she snaps the curtains shut; or rather, they close of their own accord, as if under the influence of a spell. The whole process is repeated a few minutes later, and at regular intervals throughout the day.

Most visitors probably don't notice this little performance, which is all the more pleasurable for being unexpected. But it is

more than a gratuitous bit of theater, or a preview of coming attractions. In a truly novel way, the Wicked Queen's surprise appearance sets the stage dramatically for our imaginative engagement with the ride. When we find ourselves coming under the scrutiny of her furtive glare, we ourselves are being cast in the role of the cartoon Snow White—secretly observed and menaced by a malevolent force. Once inside the ride, we realize even more fully that we are to identify ourselves with the Snow White character. As the ride is structured, once the character of Snow White is established, she disappears from the ensuing action as a *depicted figure*. In the void created, we ourselves enter the simulated cartoon created by the ride. *We* become the ones pursued by the Wicked Queen. Snow

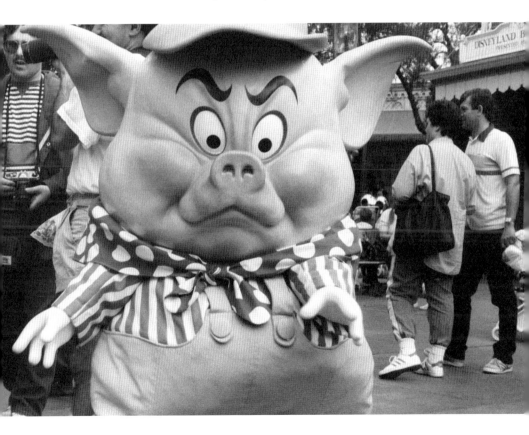

White's scary adventures happen to *us*. It is *our lives* that are in mortal danger.

Considering Disneyland's sugar-coated reputation, the Snow White ride is exceptionally graphic about the Queen's murderous plans for her intended victim. It devotes a permanent installation at the entrance—replete with gargoyles, skulls, serpents, and other stock horror effects—just to illustrate the recipe for the fatal elixir the Queen will prepare for Snow White: *One taste and the victim's eyes / will close forever / in the Sleeping Death.* Now "Sleeping Death" is pretty extreme language in a ride meant primarily for small children. No wonder the strongest memory I have of my first visit to Disneyland at age 6 is the unmitigated terror I experienced in Snow White's Scary Adventures. Yet even though the ride threatens us with a lurid death, and brings us repeatedly to the brink of the ultimate moment when the threat will be carried out, we never experience the worst. Within the conventions of the storybook-ride form, the threat of death is made immediate and real in every way except one: There are no consequences. The message conveyed is one we all want to hear: Death cannot touch us; we will always be safe.

Let's return to the Wicked Queen in the window for a moment. Though her presence there is a prelude to the dramatic interaction we will experience in the ride, in the public space of the courtyard she is simultaneously inside and outside the fictive frame—not only a character playing a defined part within the Snow White tale, but also an emblem with a more generalized meaning. The Queen represents what, in Disneyland's terms, amounts to pure evil: mortality itself, the brute fact that we grow old and die. In Disneyland, wickedness may sometimes be a matter of moral corruption or some other form of degradation, but it almost always involves a threat of annihilation directed toward things young and vital. What makes the Wicked Queen wicked is her uncontrollable jealousy of Snow White's beauty and freshness. She is jealous because, as her Magic Mirror reveals, she is really a hideous witch, old and repulsive. She possesses through illusion what Snow White possesses in fact: the beauty of her youth. Enraged by the affront of the girl's beauty—a stinging reminder that she herself is subject

to decay and death, that she will never regain the bloom of youth—the Queen vows to destroy Snow White. One bite of the apple, and Snow White, like Eve, will taste the terrible knowledge of suffering and death.

Of course, when you're in the ride, so much happens so quickly that you don't have a chance to dwell on these motivations. What you experience is the dramatic conflict reduced to its simplest terms: the Wicked Queen-witch's effort to get Snow White—i.e., you—to eat a poisoned apple. The ride is played out through a series of vivid hallucinatory scenes. In one, we enter a pestilential dungeon where the fountains flow with blood and the slain bodies of the Queen's past victims have rotted to skeletons in their futile attempts to escape. Over and over again, with the repetitive insistence of a nightmare, the figure of the witch tries to thrust the deadly apple into our hands. With each lurch of our mechanized buggies, we escape her clutches, only to encounter the hag again. The cartoon of which we're the star is a desperate attempt to elude the witch and, symbolically, thwart death—to remain beautiful and young forever.

In the Snow White ride that's precisely what we do. The ride's wild finale has our friends the Dwarfs scrambling to prevent the witch, who is perched on a crag above our heads, from crashing a huge boulder on top of us. The rocks quiver, the music swells, the witch cackles . . . we're done for. Then boom! Suddenly we burst into the light through the final door, and everything's OK; it was all a bad dream. The ride is over. As we exit, we see a huge image of a lavishly illustrated storybook page which, in a non sequitur to end all non sequiturs, announces: *And they lived happily ever after.* Odder still, the illustration shows Snow White dancing in the arms of her handsome Prince. This makes no sense in conventional narrative terms because the Prince doesn't appear in the ride. But, as it turns out, the ride is not Snow White's story anyway, it's our story, the cartoon of how we faced up to the evil forces deployed in vast array to destroy us, to deprive us of our youth and beauty—and won.

All of Disneyland, in fact, is a place where we become the heroes of highly structured cartoon-like fantasies about overcoming,

neutralizing, or denying our own mortality. Here, we are all Snow White, shadowed by—yet protected from—death. The Wicked Queen peering down at us from her window can plot our doom all she wants, can summon a host of evil powers to inflict the mortal blow, but in the cartoon wish-fulfillment logic that reigns at Disneyland, she will never succeed. Like Pinocchio, we'll be sneezed from the belly of Monstro the whale; or like Sleeping Beauty, awakened by a kiss. Even if, like Mr. Toad, we die and go to Hell, we'll spring back to life when our buggy emerges from the darkness of a world whose wonders and demons can't harm us. For here we have escaped to a world beyond corrosion and death. Here, or so Disneyland would have us imagine, we are immortal.

<center>II</center>

True to the spirit of their fairy- and folk-tale sources, Snow White's Scary Adventures and other Fantasyland rides at Disneyland portray the perils of being a living, time-bound mortal as a conflict between adult tormentors and child victims. The rides typically cast us in the role of children pursued by grown-ups who would harm us. In fleeing from the Wicked Queen, or the carnival puppeteer Stromboli in Pinocchio, or Captain Hook in Peter Pan, or the Queen of Hearts in Alice in Wonderland, we attempt to elude vicious adults who wish to murder us ("Off with her head!") or fatally ensnare us in their degenerate schemes. At Disneyland, children don't become adults; rather, adults kill children. Frightened and alone, the child's only allies are imaginary creatures like fairies and gnomes and, of course, friendly forest animals (and the occasional insect). Yet in ride after ride, the child emerges triumphant and unscathed.

Clearly the brute facts of human temporal and biological existence are issues distressing to the presiding ethos of Disneyland. Indeed, much of the poignancy of Disneyland derives from its heroically perverse effort not merely to simulate but to *actualize* a kind of counter-reality, predicated on an imagined point in childhood before we developed an adult awareness of our own mortality—a world outside of time, beyond the reach of natural laws,

exempt from pain and loss and dying. In short, the world of the cartoon.

That Disneyland is a place where cartoons "come to life" is a cliché, but one worth examining. Ever since Disneyland's beginnings—and this is especially true today—not all the attractions have been directly based on the animated products of the Disney studios. Nevertheless, a *cartoon sensibility*—a liberating sense of the limitless malleability of pictorial space, a freedom to render anything and everything that can be imagined as if it actually existed—has been and remains the shaping principle and conceptual underpinning of Disneyland.

As a formal category of illustration, cartoons have traditionally played fast and loose with conventional representation. Artists were fracturing and reshaping recognizable reality in cartoons for humorous or satirical effect long before technology made it possible for painted figures to move when projected on a screen. With the advent of cartoon animation, a new kind of canvas was created, no longer pictorially inert, upon which illustrated figures not only materialized but interacted within a depicted spatial environment. A single picture once created could be sustained in a succession of images over time, and the images themselves manipulated to convey figures engaged in an internally coherent dramatic action on a constantly metamorphosing visual field. Such a field and the forms it contains were and are, to all appearances, animated—literally inspirited, given breath, quickened with the seeming pulse of life.

With virtually unlimited visual resources available to the animator, cartoons are able to create a self-contained world which, though clearly artificial, has a life all its own. This two-dimensional cartoon world is the paradigm that Disneyland aspires to create in three dimensions, as a kind of "living cartoon." But that oxymoron should give us pause. If static drawings are brought to life by cartoon animation, what is supposed to be happening when the animation itself becomes animated—when the illusion of life created in the cartoon steps out of the screen and into "real life"?

Let's try to answer that question by considering animated cartoon characters and their world for a moment. They may have

no physical being except as individual animation cels and pieces of film, but by a trick of perception we nonetheless observe them walk, talk, run (usually pursued by another character), and otherwise perform actions which are recognizable if not always realistic. But no matter how non-naturalistic or outrageous the image, we—and children in particular—tend to perceive it as an independently existing reality. What we see on a movie or TV screen could be, for all intents and purposes, actual or staged events photographed in a separate world—a peculiar and brightly lit one, inhabited by an odd assortment of creatures whom we often see from perspectives inaccessible to even the most sophisticated camera. This cartoon reality convinces us to perceive a character called Donald Duck as no more and no less a living, functioning agent in the world he inhabits than, say, Sam Spade is in his. But Sam Spade exists in a different relation to life than does Donald Duck. Sam Spade is a representation of a biological human being who could be alive in our world, or a world similar to our own, whereas Donald Duck could never be biologically alive. The world of Sam Spade is a world structured like our own, in which human death brings the individual's organic development, sensory capabilities, and personality to a permanent close. In his world, Sam Spade is at every moment susceptible to physical deterioration, suffering, disease, or violent death. But Donald Duck is, for want of a better term, immortal; having never been alive, he can never die.

So the world of cartoon animation is a crazy place that is not just a caricature of our real world, but a wholly distinct restructuring of experience—a place where there is life but no death, forms of life but no living beings, and where things that don't materially exist can be real nonetheless. What Disneyland seeks to approximate as closely as possible is a permanent cartoon that doesn't dissolve like a phantasm when the projector is turned off. Disneyland's effort to build a self-contained "kingdom" where our spatial and temporal world can intersect and merge with the cartoon world amounts almost to a second Creation—a re-imagining, a reimaging of the world as it might be if death were impossible, if the taint of our biological existence could be cleansed and replaced by a pure, blood-

less, and deathless alternative life. God had clay when He molded Adam in His image and endowed him with a soul on the sixth day of Creation; Walt Disney had audioanimatronics.

Of all the resources of stagecraft, puppetry, and engineering used at Disneyland to wrench the cartoon world off the screen and into the physical world, audioanimatronics is the most important. It was the first of many remarkable feats of state-of-the-art illusionism at Disneyland aimed at breaking down barriers between the aesthetically detached image and real phenomena—culminating in the pointlessly spectacular 3-D effects of Captain EO and the gut-wrenching simulated space ride in Star Tours. Walt Disney, who regarded audioanimatronics as one of his crowning achievements, had the inspiration for his invention one day when he became fascinated by a singing mechanical bird in a gold cage on his desk. Like a modern entrepreneurial version of Yeats' drowsy emperor from the *Byzantium* poems (who was kept awake by the song of an artificial bird on a golden bough), Disney set about developing a vast population of humanoid and anthropomorphic puppets electronically programmed to twitch and gesture in sync with a prerecorded vocal and musical soundtrack—as in Yeats' verse, with bodily forms not taken from "any natural thing," mouths with "no moisture and no breath," singing eternally of "what is past, passing or to come" (echoes of Disneyland's worlds of "yesterday, tomorrow, and fantasy"). Disney reportedly joked that his automated performing figures were cheaper and more dependable—hence, more economically viable for Disneyland's needs—than real human actors.

We are now in a position to tackle the question posed at the beginning of this essay: *Why is the museum-like shrine to Walt Disney on Main Street USA at Disneyland paired with an audio-animatronic resurrection of the most famous assassination victim in American history—Abraham Lincoln?* Great Moments with Mr. Lincoln is a seemingly innocuous display of schmaltzy Americana, which most tourists don't even bother to visit; yet in it we see perhaps the best example of the particular form of necromancy practiced at Disneyland, and what's behind all the magic of the so-called

Magic Kingdom.

An apostle of progress, Walt Disney took pride in all of the technological innovations showcased at Disneyland (and later at Epcot Center), but he obviously wished to be remembered for, and associated with, the development of audioanimatronics. One of his fondest projects was the creation of a Hall of Presidents, a patriotic necrophiliac's wet dream eventually built at Disney World in Florida, featuring audioanimatronic replicas of all the U.S. Presidents, simultaneously immortalized on stage in the ultimate collapsing of distinctions between time and space, life and death. Surprisingly, Abraham Lincoln, not George Washington, was the first President to come in for high-tech exhumation—reanimated like something out of H.P. Lovecraft. Except Disney's Lincoln was never dead in the first place, but lovingly fabricated by Disney artisans "in glory of changeless metal" (Yeats again) and latex, using Lincoln's actual death mask as a model for sculpting the facial features.

The choice of Lincoln as the first to be robotically recreated is no accident. Nothing at Disneyland is accidental. It is entirely consistent with Disneyland's overall effort to negate or neutralize death through immortality-granting scenarios which visitors are invited to enact, in various forms, again and again. His historical significance and greatness aside, Lincoln is the one President (apart from Washington) whom American children are taught to idolize with an almost religious reverence, and the one President (apart from J.F.K.) who is as famous for the very fact and manner of his death as for anything he did while alive. It is virtually impossible to conceive of Lincoln without revisiting the circumstances of his death. We don't think of Washington or Jefferson or Roosevelt as Presidents who are dead in the same way Lincoln is imprinted on our minds as a President *who died*. That's what makes it all the more eerie and startling to encounter an *un*-dead Lincoln as we do at Disneyland.

As we sit respectfully in the darkened theater being lectured by a motorized mannequin, we begin to realize that what we're meant to see is not an actor impersonating Lincoln, nor even a mechanized clone purporting to represent the real Lincoln—but an

altogether new and improved *kind* of Lincoln. This is a Lincoln who has stepped out of a cartoon of American history—the same cartoon reality of Donald Duck, where there is no life and no death, only the ceaseless repetition of gestures without motives, actions without consequences. Strictly speaking, we are not even being asked to imagine that we have been transported back in time to hear an address by Lincoln; there is no dramatic situation or fictive context whatsoever, just Lincoln himself, big as life, palpably real but not alive. Disney's Mr. Lincoln materializes in our present moment from a no-time which is at once all times and beyond the reach of time, a moment of pure imagining—an eternally existing possibility, like heaven. This Lincoln's presence brings us into contact, however briefly, with a distinct other world—not a fictional world depicting life as it might have been if Lincoln had never been killed, but a *real* world, a cartoon reality in which Lincoln *could not have been killed*.

Disneyland itself clearly was conceived as an attempt to embody such a world, or at least create an appropriate milieu in which the cartoon world and ours could overlap. For Walt Disney, it was evidently not enough merely to give us glimpses of that world on a movie screen; he wanted to enter it, to experience the bloodless immortality of created images. In Great Moments With Mr. Lincoln, he attempts the ultimate fulfillment of the promise of animation: to raise the dead. The placement of the Walt Disney Museum next to Mr. Lincoln strongly suggests that Disney wanted to be forever identified as chief artificer of this feat—assuring himself a kind of personal immortality as a manufacturer of marvels, a beneficent ruler-magician in whose kingdom death holds no sway. Yet at the heart of Disneyland is a wish even more impossible and sad than the defeat of death: a wish to exist in a cartoon outside of time, a wondrous artificial America in which nothing can ever be lost, where all times, places, and cultures exist side by side, where flowers are always blooming and children can't grow old and the icons children are taught to venerate, like Lincoln, can't die. If our mortality prevents us from actually living in that world, Disneyland employs enormous ingenuity in showing us not only what it looks like, but

how it feels. This is the true dark side of Disneyland: Our contact with the cartoon realm suggests that our own lives are rather paltry things, inferior to mere figments—that there is something shameful about our very biological existence.

But there is an ennobling side to all of this as well. For Disneyland is also an enormously complex work of art that memorializes forms of thinking, feeling, and perceiving we no longer remember and can never reëxperience. Here, bodied forth before our eyes, is the wish-fulfillment world in which, as children, we once believed, without knowing we believed. In striving at every turn to obliterate all distinctions between the real and the imagined, the actual and the possible, Disneyland disarms our adult responses and places us once more in the position of children, uncritically alive to any source of pleasure, excitement, and instruction, without drawing lines between fact and fantasy. In doing so, Disneyland seeks to resurrect—to reanimate and make immortal—what time, in the non-cartoon world, destroys. The fact that Disneyland comes so close to achieving this ambition, yet fails so absolutely, is what makes it a much more profound and sadder experience than its surface merriment belies. The "happiest place on earth" is less an amusement park than a moving elegy for dead children.

About the Authors

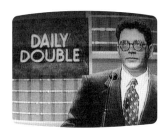

Bernard Welt is chairman of the Department of Academic Studies at the Corcoran School of Art in Washington, D.C., where he teaches interdisciplinary courses in the humanities, including the history of cinema. He is the author of a book of poetry, *Serenade* (Z Press, 1980), and has written essays on books, film, and art for *The Washington Post*, *washington review of the arts*, *Lambda Book Report*, *The Washington Blade*, and other magazines. He was awarded a National Endowment for the Arts Creative Writers Fellowship in 1980. On May 28, 1992, he was champion on the television game show *JEOPARDY!*

Donald Britton was born in 1951 in San Angelo, Texas, and died in 1994 in Los Angeles. He was author of a book of poetry, *Italy* (Little Caesar Press, 1981), and his poems appeared in *The Paris Review*, *Christopher Street*, and other literary magazines.

"Literate, sometimes quirky, insightful criticism . . . a crack in the boosterish, public relations mentality."

—*Los Angeles Times*, April 8, 1990

Art issues. Press
Los Angeles

**Last Chance for Eden: Selected Art Criticism
by Christopher Knight 1979-1994**
Edited by MaLin Wilson
Introduction by Dave Hickey
440 pages; 78 illustrations

The World of Jeffrey Vallance: Collected Writings 1978-1994
Edited by David A. Greene and Gary Kornblau
Introduction by Dave Hickey
112 pages; 40 illustrations

The Invisible Dragon: Four Essays on Beauty
by Dave Hickey
Winner of the Frank Jewett Mather Award for distinction in art criticism
64 pages; 8 illustrations

Art issues., a bimonthly journal of contemporary art criticism.

To order or for more information contact:

Art issues. Press
8721 Santa Monica Boulevard, #6
Los Angeles, CA 90069
Telephone (213) 876-4508

Distributed through D.A.P.
636 Broadway, 12th Floor
New York, NY 10012
Telephone (800) 338-BOOK